IMAGES
of America

MIDDLETON

IMAGES
of America

MIDDLETON

Shirley Paul Raynard
with the Middleton Historical Society

ARCADIA
PUBLISHING

Published by Arcadia Publishing
Charleston SC, Chicago IL, Portsmouth NH, San Francisco CA

Printed in the United States of America

Library of Congress Control Number: 2009938114

For all general information contact Arcadia Publishing at:
Telephone 843-853-2070
Fax 843-853-0044
E-mail sales@arcadiapublishing.com
For customer service and orders:
Toll-Free 1-888-313-2665

Visit us on the Internet at www.arcadiapublishing.com

To Edward L. Raynard and my children, Robert and Nicole Raynard,
William and Patricia Raynard, and for my grandchildren, Isabelle
and Austin Raynard, and Liza and Diya Raynard with love.
I hope this book will have value for generations to come.

CONTENTS

ACKNOWLEDGMENTS

The writing of this book has been an exciting journey through the history of my own town. I am grateful to the Middleton Historical Society and its members for the wonderful support and help I have received. I especially wish to acknowledge the dedicated curators Marge Watson and Rita Kelley, who have spent endless hours gathering, organizing, and maintaining the superb museum collection. The president, Henry Tragert, has also been very supportive of this undertaking, for which I am most grateful. To my friend Annette V. Janes, this book would not have been possible without your help and support.

All the images in this book are from Middleton Historical Society's extensive collection.

INTRODUCTION

Middleton, a shortened name for middle town, is halfway between the two important towns of Andover and Salem. The town was formed from parts of Salem Village (now Danvers), Topsfield, Boxford, Rowley, and Andover. It was a hardship in the 1700s for people to travel to church from Middleton to those towns due to inclement weather and sometimes impassable roads. Before attaining the name of Middleton, the area was known as Will's Hill after a lone elderly Native American named Will, who lived on the "great hill" overlooking Middleton Pond. There was sufficient land to form a separate town.

William Nichols was the first white European to settle in 1651. In 1659, Bray Wilkins settled near Middleton Pond on Will's Hill with his six sons and John Gingell, a family friend from Lynn, Massachusetts. In 1653, Thomas Fuller, a blacksmith from Woburn, built a sawmill on the brook that ran from the pond to the Ipswich River. Other settlers were the Putnams, Hobbs, Elliots, Townes, Richardsons, and Peabodys. Even before these first settlers arrived, the "Great Oak" was growing in a meadow nearby. This amazing tree is thought to be over 400 years old and is a national landmark.

The Province of Massachusetts Bay gave permission to form a new parish, providing that the new town construct a suitable place of worship and engage a minister and a schoolmaster. The first town meeting was held on July 9, 1728, and received its charter at that time. A sign located on Maple Street (modern Route 62) stands today on the first town meeting site. The church, which also served as the meetinghouse, was already under construction nearby. The Reverend Andrew Peters, a Harvard graduate, was ordained as its first minister on November 6, 1729. Nathaniel Towne was the first schoolmaster. He taught in Middleton for over 10 years.

The small village of Middleton did not escape the hysteria of the witchcraft trials of 1692–1693. John Willard, one of the settlers, was hanged as a witch on Gallows Hill in Salem. The Hobbs family—father, mother, and daughter—were tried as witches but fortunately were not executed.

The well-trod Native American paths soon turned into well-used roads for wagons and horses and then later into county and state highways. Two steam railroads, a trolley car line, and a major bus route later ran between Salem and Lawrence, stopping in the middle at Middleton.

The Estey Tavern, built in 1753, was used as a stopover by travelers and drovers alike. A town pound was established across the street to hold the drovers' sheep, cows, and horses. A watering trough was located in the very center of town for the animals and travelers.

Middleton was—and remains to this day—a very caring, helpful, and harmonious community. Church groups have helped other church groups, and neighbors help other townspeople regardless of their race, creed, or ethnicity. The social life and organizations have been formed to aid and assist others and to benefit the general population.

From the 17th century to the present, Middletonians have been industrious, hardworking, and innovative. The town was primarily agricultural, and remained so to the mid-1900s. Yankee ingenuity took advantage of all the available resources. The Ipswich River, vast woodlands, abundant meadows, and the availability of the roadways and public transportation allowed the people to prosper, yet maintain a rural and agricultural community.

The Ipswich River, Middleton Pond, and all the small ponds and streams in the area have given it a bucolic and rural setting. Once better roads and public transportation became available, Middleton became a popular recreational destination. Summer cottages, camping areas, picnic groves, and resort boardinghouses brought visitors from the major area cities, such as Boston, Lynn, and Salem.

There are still over 20 houses in Middleton that were originally built in the 17th and 18th centuries. Middleton grew slowly and steadily throughout the 19th century. The Middleton Historical Society has a large collection of photographs of these unique homes and homesteads. In the mid-1900s, Middleton saw a large increase in residential homes as people discovered this desirable small town with all its beauty and nurturing atmosphere.

The townspeople of Middleton have always valued education. The earliest schools in the town were in private homes, allowing only a few pupils to come together. Later the town built four one-room schoolhouses in different parts of town—north, south, east, and west. (The north and east schools are still standing as private residences.) This system prevailed until 1860, when the Centre School was built. Now much enlarged, this edifice known as Memorial Hall in honor of Civil War veterans still stands and is presently used as town offices. The town now has two large elementary schools—the Howe-Manning and Fuller Meadow Schools. In September 1959, the towns of Boxford, Topsfield, and Middleton joined together to form the Masconomet Regional Junior and Senior High School.

The town has been well represented in all wars, beginning with King Philip's War in 1675. In the Battle of Lexington and Concord, many of the men walked or rode horseback across the country to assist the minutemen in routing the British. In front of the Flint Public Library are monuments listing the brave men and women from Middleton who have served their country. Every Memorial Day there is a solemn ceremony and parade to honor veterans.

One of the earliest "Social Libraries" in Massachusetts was founded in Middleton in 1772. Many of the books in this first library are in a special collection now housed in the Flint Public Library. The present Flint Public Library was built in 1891 with a $10,000 bequest left to the town by Charles L. Flint for the purpose of building a public library accessible to all without charge. The library, the lifelong educating institution for all ages, is the heart of the wonderful community of Middleton. The many dedicated public servants, police, firefighters, teachers, and volunteers who serve on town boards, departments, and committees and caring people have made this small New England town the outstanding place it is.

One

CHIEF WILL AND MIDDLETON'S WITCHES

Through the woods and valleys of New England, the Algonquin Nation flourished until the arrival of the Europeans. Though early records show that Europeans arrived in the 1600s, it is now known that the coast was visited as early as the 1500s, and perhaps earlier. The arrival of these early adventurers brought with them disease that Native Americans had no immunity to, and as a result they died by the thousands.

Will's Hill, the area that was later to become Middleton, was part of Salem Village. The name refers to a Native American known as Will, who lived on the hill north of Middleton Pond. There is a legend that on top of Will's Hill there is a stone chair where he sat to view the valley and pond below. There is also a slab of stone that according to legend was used by Chief Will and his tribal members to grind corn and other grains. Townspeople of Middleton still honor Chief Will with a special day of celebration each year in July. Chief Will's spirit of selflessness and generosity is continued by the townspeople of Middleton to this day.

Will's Hill did not escape the scourge of the witchcraft hysteria that swept the area. In 1692, John Willard was a constable whose job it was to serve warrants on people accused of witchcraft and take them into custody at Salem Village. Willard was often sympathetic to the accused, and a deluge of accusations came down upon him. The final blow came when John Willard was accused by his grandfather-in-law, Bray Wilkins, of making him very ill. This accusation sounds foolish in modern times, but not in the hysteria of 1692. In August 1692, John Willard was taken into custody and tried and hanged as a witch on Gallows' Hill in Salem. Willard's body was buried near his farm on the corner of Liberty and Peabody Streets. The Nichols family of the Locust Street area were also accused as witches, but their lives were spared.

The Middleton Historical Society erected a monument in Willard's memory on the grounds at their museum.

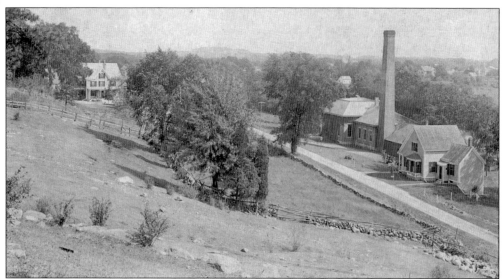

A View from Will's Hill. This photograph taken in the late 1950s shows the Danvers Water Department buildings, including the caretaker's home. It replaced the reservoir on the top of Will's Hill. In the left corner is a house built on the original site of the early Bray Wilkins homestead.

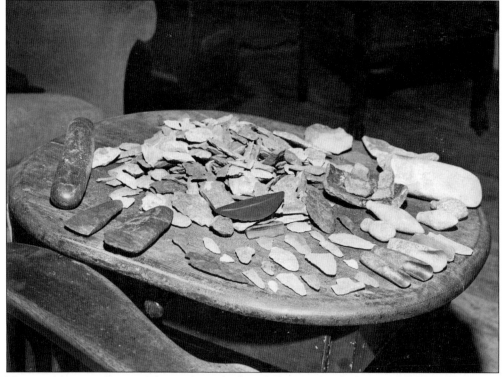

Native American Relics. These relics, which include arrowheads, axes, tomahawks, drills, and large pestles, are owned by the Lura Woodside Watkins Museum in Middleton. Many were found on Chief Will's Hill and along the Ipswich River. Arthur Curtis, a local farmer, was one of the townsfolk who unearthed and preserved many artifacts. This collection is considered one of the finest in New England.

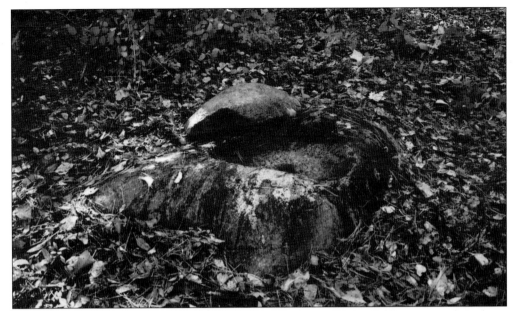

CHIEF WILL'S BOWL. This photograph shows a stone on top of Will's Hill believed to have been used by Chief Will and his family to grind corn. Also located on the hill is a stone formation that resembles a throne. Many children have fond memories of sitting there pretending they were the old chief.

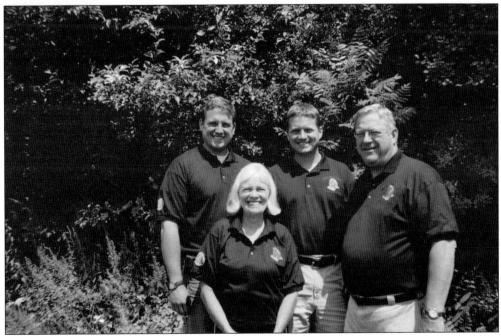

CHIEF WILL'S DAY. The Richardsons are wearing Chief Will's Day T-shirts for the annual celebration. Pictured from left to right are (first row) Susan; (second row) Chris, Peter, and Paul. The Richardson family has been instrumental in promoting this special celebration in honor of Chief Will. Townspeople enjoy this wonderful homecoming day that brings the town together each summer. The event ends with spectacular fireworks.

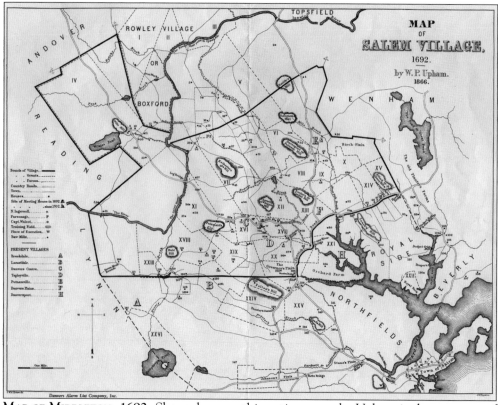

MAP OF MIDDLETON, 1692. Shown here on this antique map by Upham is the vast area of Salem Village in 1692, long before Middleton was incorporated as a town in 1728. Also shown is the historical road from Salem to Andover and the "great waterway" now known as the Ipswich River.

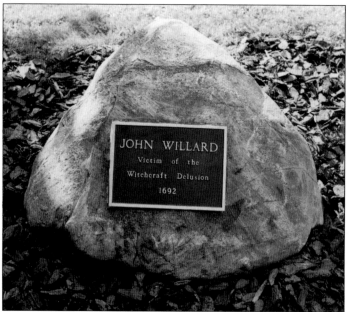

WILLARD MEMORIAL STONE. This stone commemorating Middleton's only victim of the witch hunts is located on the grounds of the Middleton Historical Society Museum on Pleasant Street adjacent to the Flint Public Library. The ceremony took place on September 13, 1992, and commemorated the 300th anniversary of the execution of John Willard.

Two

Essex Turnpike and Middleton's Early Transportation

The first roads to Middleton were old Native American footpaths. These were replaced by trails formed and traversed by the early settlers on horseback and later with carts drawn by oxen and horses.

The arrival of railroad transportation was very important to the people of Middleton. In 1848, the Essex Railroad began its run through town, originating in Salem and terminating in Lawrence. The first stop in Middleton was on lower Central Street, where there was a turntable that enabled the trains to return to Salem. Trains allowed people to travel to Boston and back in one day, previously a trip of several days or at least overnight. People could go to Salem or Lawrence to shop and sell their agricultural produce. Youngsters could attend the classes at Salem Normal School (now Salem State College.)

Benjamin Howe, a onetime state representative, opened Howe's Station in the eastern part of town. He used the railroad regularly to go to Boston to serve in the legislature.

The Salem and Lowell Railroad began August 5, 1850. It ran from south Danvers and Peabody to Wilmington and on to Lowell. In Wilmington, Middleton passengers could change trains and board a train to Boston. South Middleton Station was called Oakdale on railroad tickets. Middleton townsfolk referred to it as South Middleton or the Paper Mill Station. In those pious times, there was no train service on Sunday.

The Essex Turnpike (now Route 114) was built from 1806 to 1914, taking over 100 years to complete. It ran from Danvers to North Andover, Massachusetts.

In 1901, an electric trolley car service began in Middleton, running from Danvers to Lawrence. Trolley cars ran parallel to the roads, with 16 to 20 feet on the side to allow for other road traffic. Many of the trolley line's embankments remain and can be seen today in the woods and fields. The electric trolley car service lasted for 34 years, replaced by the Eastern Mass Bus Company.

Soon private cars replaced public transportation. There is no public transportation in 2010.

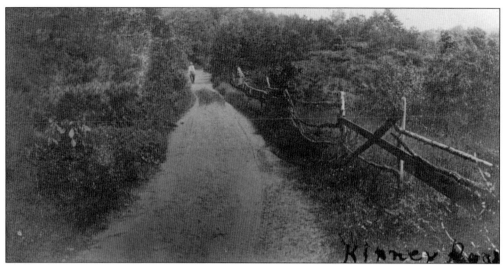

OLD NATIVE AMERICAN PATH. Kenney Road next to the Ipswich River was traversed by Native Americans for centuries. Many New England roads followed the example set by Native American pathways. The Kenney family established one of the oldest homesteads in town. Their house is no longer standing, but there are many other residences located along this road.

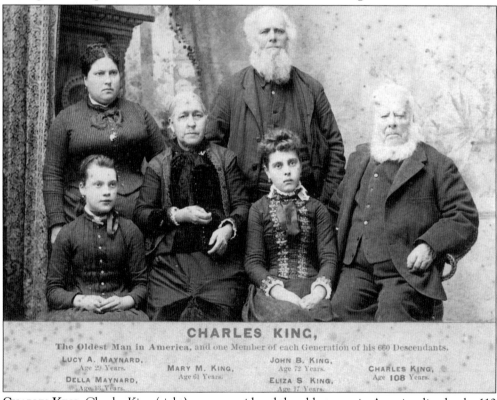

CHARLES KING,
The Oldest Man in America, and one Member of each Generation of his 660 Descendants.

LUCY A. MAYNARD, Age 29 Years.		JOHN B. KING, Age 72 Years.	
MARY M. KING, Age 61 Years.			CHARLES KING, Age 108 Years.
DELLA MAYNARD, Age 13 Years.		ELIZA S KING, Age 17 Years.	

CHARLES KING. Charles King (right), once considered the oldest man in America, lived to be 110 years old and lived on Kenney Road. This photograph shows six generations of the King family. King's Pool, located on the site of his old homestead, was a popular swimming hole for many years. Many locals have happy memories of learning to swim at King's Pool.

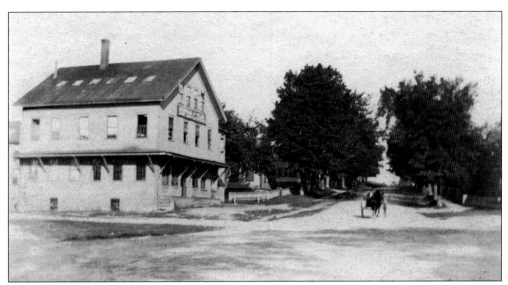

ONE-HORSE BUGGY. Most families in Middleton had a buggy, a wagon, or both. This photograph shows the dirt road that became Route 114 North. The author has memories of riding in one of these conveyances. In the winter, people traversed the road in a sleigh or pung using one or more horses.

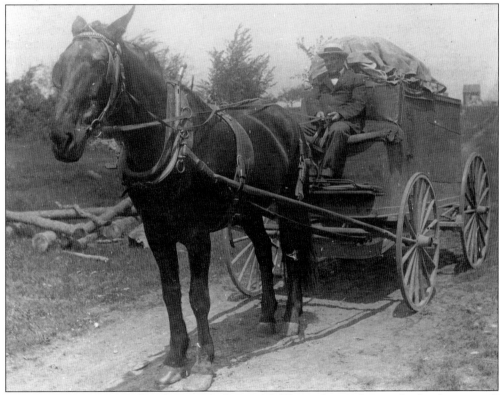

FAMILY WAGON, 1900S. This photograph shows a Middleton farmer driving the family wagon all dressed in Sunday go-to-meeting clothes. It was not always possible to arrive at church in neat attire during inclement weather. In very cold weather, farmers brought heated stones to church to keep their feet from freezing.

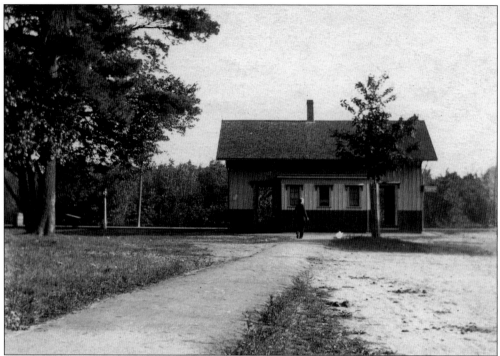

CENTRAL STREET STATION. The Essex Railroad stopped at the Central Street Station from 1848 to 1926. During this time, a turntable was installed on the site to allow engines to be turned. It took six or seven men to turn the engine around. This is now the site of the parking lot for Howe-Manning School teachers.

TRAIN WATER TOWER. The water tower was built in 1845. This picture shows members of the Young family of Mount Vernon Street posing around 1940 in front of the water tower, which had fallen into disrepair. The tower was moved by the Peter Rubchinuk family of East Street and used as a bonfire at the annual fireman's Carnival behind the Howe-Manning School.

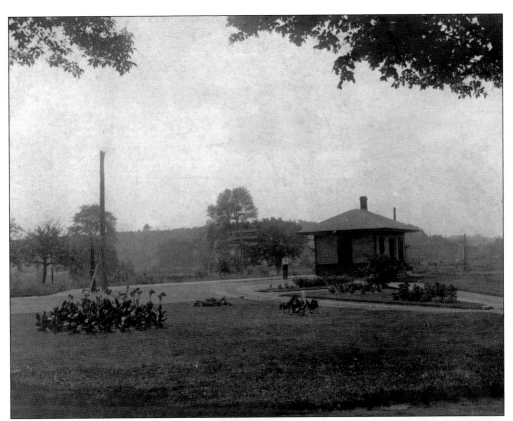

HOWE STATION. The introduction of the railroad made a huge impact on Middleton. This station, made famous by Rep. Benjamin Howe, was later relocated to be used as a residence. It is the fourth house on the right on East Street and is still occupied as a residence.

TRAMP HOUSE. This house was built in 1878 by Charles Flint with the help of his son and the Phelps brothers in two weeks' time. In return for overnight shelter, the vagrants who stayed there were expected to chop wood. Said to be the only one left in Massachusetts, it housed tramps or vagrants who could live there as long as they earned their keep. There was a stove, beds, and blankets but no conveniences.

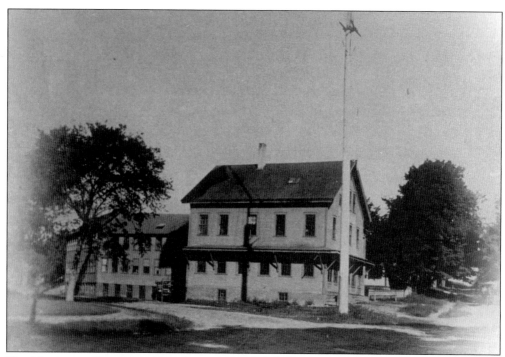

THE MIDDLETON FLAG POLE. This flag was a landmark that many of the older folk remember with fondness. Shown here in the early 1900s is Old Glory flying proudly above Middleton Square. Seen here also is the Merriam and Tyler shoe factory on the corner of North Main and Lake Streets.

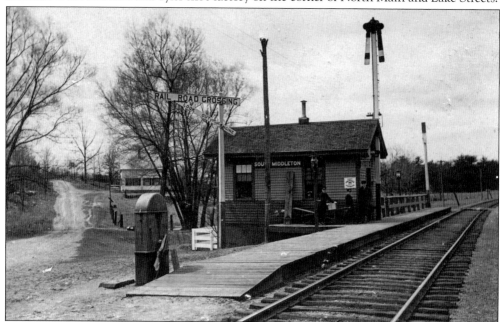

OAKDALE STOP. Above is the Salem and Lowell Railroad stop in South Middleton, which was named Oakdale by the railroad authorities but called South Middleton or Paper Mill Station by town folk. This train line allowed Middleton residents to change lines in Wilmington to go to Boston and back.

18

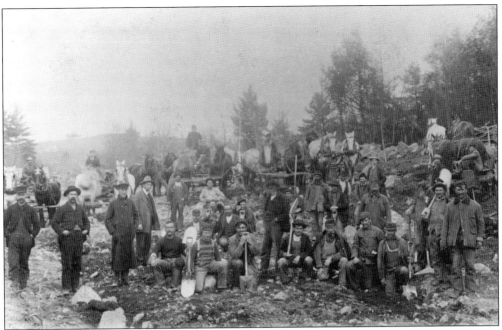

WORKERS. Pick and shovel workers are shown here building Route 114 through North Main Street from Middleton Square to North Andover. Local farmers were happy to have the extra income for working on the road. The mode of dress was formal in spite of the hard manual labor, and weather often delayed the work for days or weeks at a time.

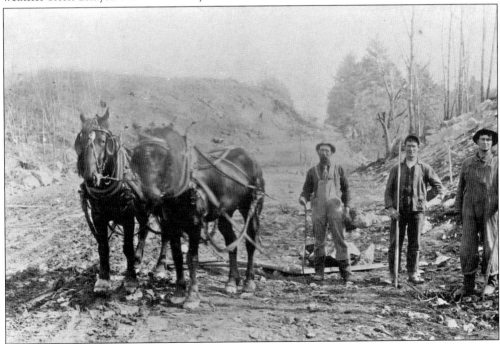

IRISH WORKMEN. In this picture, Irish workmen are using horses to complete work on Route 114. Local farmers were paid on a daily basis for the use of their horses—another source of income for the local folk. These heavy, powerful horses were not for recreation but were bred for hard work.

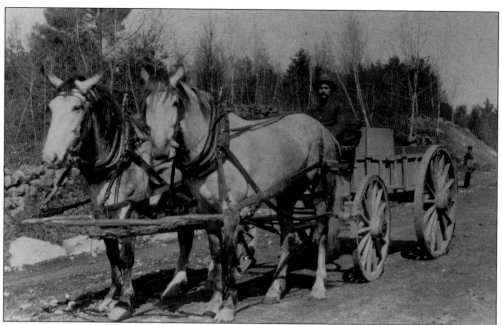

HORSES AND CONSTRUCTION. This is a photograph of horses used in the construction of the Essex Turnpike (Route 114), 1910–1914. A lot of Irish men came from Boston daily by train and had to walk several miles to work on this project. They were a rough and ready group of hardworking men.

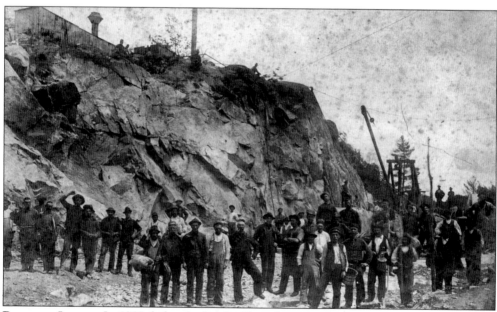

BLASTING LEDGES. In 1902, ledges had to be blasted on North Main Street to extend trolley service to Lawrence—a tremendous undertaking. Previous to this development, a trolley would go from Salem to North Main Street in Middleton and then stop. People would disembark from one trolley, walk around the massive ledge, and board another trolley to Lawrence.

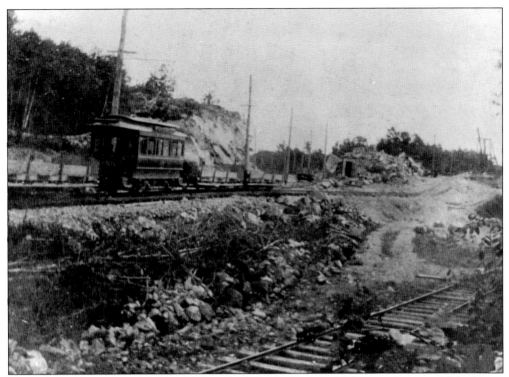

WORKING ON THE RAILWAY. This photograph shows the location of the transfer area and the laying the tracks of the Street Railway on North Main Street near a curve. There was an underground storage area for perishable goods until they could be put on the next trolley. Men were hired on a daily basis and earned a minimum wage. This area was owned by the Muzichuck family. It was a commercial/recreational area called Santa's Lookout in the 1950s.

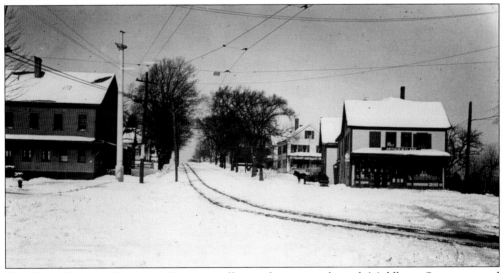

THE ESSEX TROLLEY COMPANY. Here is a trolley track running through Middleton Square around 1905. The building on right was called Clark's store, a site that continues to be of commercial use to this day. The picture depicts the sparseness of Middleton Square. The horse pictured here is standing in front of Wilkin's barn.

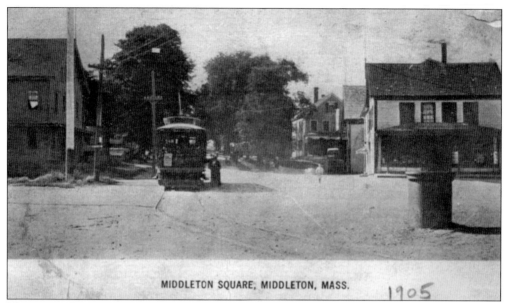

MIDDLETON SQUARE, MIDDLETON, MASS. 1905

MIDDLETON SQUARE TROLLEY, 1905. These passengers are embarking the hourly trolley. The town watering trough is seen on the right, and the original Middleton flag pole is on the left. Water from Middleton Pond supplied the trough with fresh water for the equine population. Nearly every family owned horses at the time.

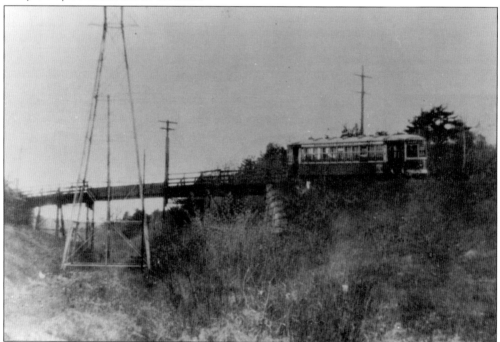

THE OVERPASS. This overpass or trestle was built in 1900. The stone foundations can still be seen on Maple Street and Oak Road near the abandoned railroad tracks. The Street Railway ran from Salem to Lawrence for 34 years, until June 15, 1935. On the last day, which was shortly after the repeal of Prohibition, the trolley company gave out beer to passengers from a large keg tied onto the back of the trolley.

THE TRESTLE. Shown here is an electric car leaving the turnout on Maple Street approaching the trestle. The electric car was an innovative and inexpensive mode of transportation for the local populace, allowing farmer's wives to travel to major cities such as Lawrence and Salem. Previously the trip had meant an overnight stay.

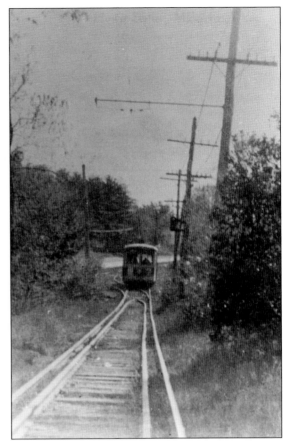

EARLY TOURING CAR. In 1917, as automobiles became more affordable, people flocked to Middleton to enjoy the clean, pure air as well as the countryside. This couple is enjoying an outing in a newfangled touring car. Drivers needed mechanical ability, as filling stations were not frequently encountered on the road.

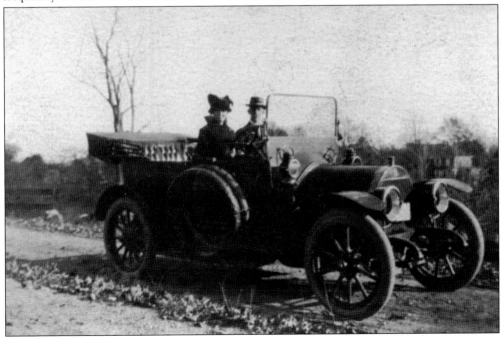

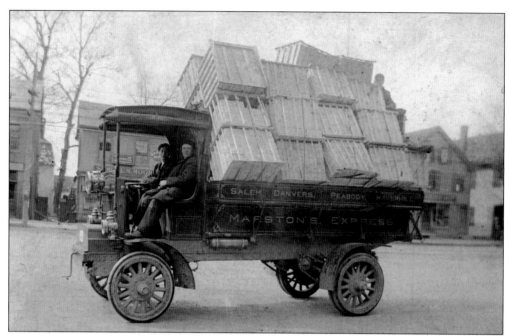

THE HORSELESS CARRIAGE. Above is a picture of one of the first horseless carriages, the Marston Express. It was slow but steady as it made deliveries from Salem to Andover via Middleton. All kinds of merchandise were carried in this labor-intensive way. Note the wooden-spoke wheels on the vehicles.

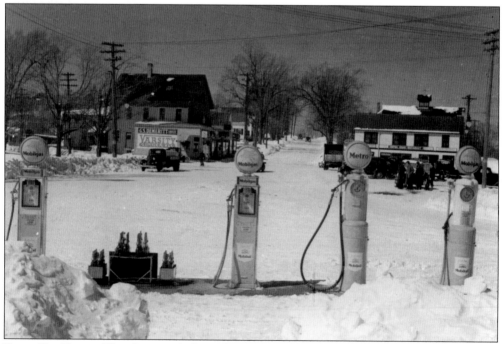

EARLY GAS PUMPS. This photograph shows the gas pumps located in the square at Stahler's Garage in March 1939. This was an innovative business enterprise at the time, located at the junction of what became Routes 62 and 114. During bad weather, the roads could be impassable for days.

HARRY (LEFT) AND GEORGE (RIGHT) STAHLER. Father and son watch the traffic go by at their garage in the center of Middleton Square in 1928. Their Chevrolet dealership was the only automobile dealership in Middleton at that time. The Stahler family generously sponsored many organizations in town. Both men served on town boards and committees.

LOOKS LIKE A LANE. In the early 1930s, a photograph of North Main Street shows an unpaved road running through Middleton Square. During a northeaster, it was common for folks to be snowbound for days. Most people made sure that they had adequate provisions to weather the storm. The Eventide Manor, a rest home for aged men and women, can be seen at the back of photograph.

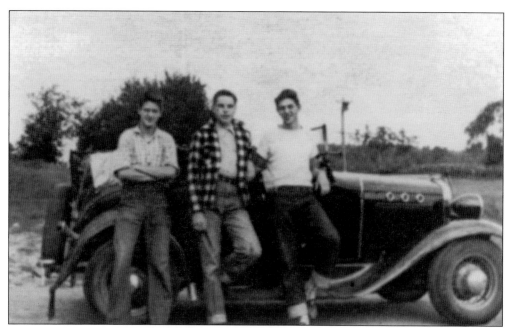

MODEL A FORD. From left to right, Alton Goodale, John Bishop, and Bill Paul proudly stand in front of Paul's 1930 Model A Ford, one of the few Model A Fords with a rumble seat. These three young men toured New England in this vehicle in 1957. Later all three became outstanding Middleton citizens.

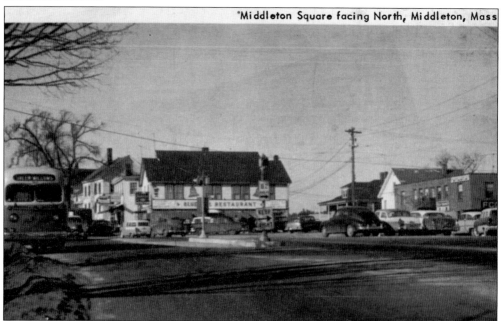

"Middleton Square facing North, Middleton, Mass

EASTERN MASS BUS COMPANY, C. 1950. The company provided transportation between the towns of Lawrence and Salem. Note the bus stating that is bound for Salem Willows Park. In the background is the Bluebell Restaurant, a fixture in the square for many years. It was run by the Joseph LeColst family, among others over the years. It is now Tonnelli's Restaurant, owned by Leith Campbell and family.

Three

MIDDLETON'S SOCIAL LIFE

Middleton folk have a reputation for sociability and generosity that lives on to the present day. Early social life in Middleton revolved around the meetinghouse, where religious services took place and the annual town meetings were held. The early schools were also a place where cultural and educational functions took place.

Middleton's scenic Ipswich River meanders through the town. Middleton Pond, Mill Pond, Pout Pond, and Aunt Beck's Pond and several small streams provided pure, fresh water and the opportunities for recreation. With the advent of the railroad, the low train fares enabled ordinary workfolk to travel. Vacation boardinghouses sprang up to meet the needs of this mobile populace, as well as taverns, inns, and lodges. One of the most popular spots from the 1800s to the 1930s was the Pavilion located on Walnut Pond (now called Middleton Pond).

In the early 1900s, many social, fraternal, musical, and athletic organizations were created. Some of the more popular in Middleton were the Grange No. 327, the King's Daughters, the Ladies Home Union, the Middleton Brass Band, the Improved Order of Redmen, Minnetuxit Tribe No. 17, the Acacia Club, the Ladies Sodality, the Ladies Home Union, town baseball teams, the American Legion, Augustus P. Gardner Post 227, the American Legion Ladies Auxiliary, the Veterans of Foreign Wars, the South Middleton Improvement Association, the Ladies Foreign Missionary Society, the Girl's Altruistic Club, the Women's Club, the Cheerio Club, the Purrettes, the Boy and Girl Scouts, the 4-H Club, the Forget-Me-Not Club, and other organizations too numerous to mention.

Evangelical tent meetings were held in the large field near the Pavilion. The late Benjamin Richardson remembered making two deliveries there on the weekends from the family farm for his father, Hazen Richardson Sr. The first delivery of milk, cream, eggs, and ice cream (when available) was at the evangelical tent area, and the second stop was at the Pavilion. Ben said he was in his youth and definitely liked delivering to the Pavilion best. Taken down in 1941, it was moved and sold in two parts to the Clay and Raynard families.

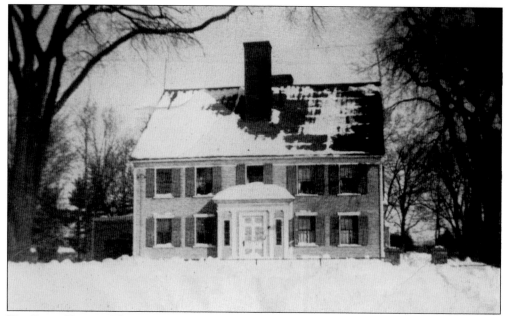

THE ESTEY TAVERN. This tavern was built in 1763 by Samuel Bradford. Later Jonathan Esty bought the tavern. Travelers and drovers made this a popular stage-run stop, as it was midway between Salem and Lawrence—two well-populated towns at the time. In 1985, the tavern was completely restored by the owner, Paul Richardson. It is listed on the National Register of Historic Places.

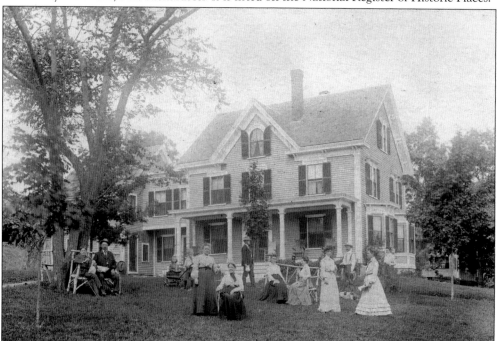

LAKEVIEW HOUSE. Lakeview House was a popular summer resort overlooking Middleton Pond. This photograph from around 1900 shows many vacationers completely dressed up even though the weather was probably very warm. Served by the Eastern Railroad, folks coming from Salem, Lynn, and the surrounding areas made this a summer destination.

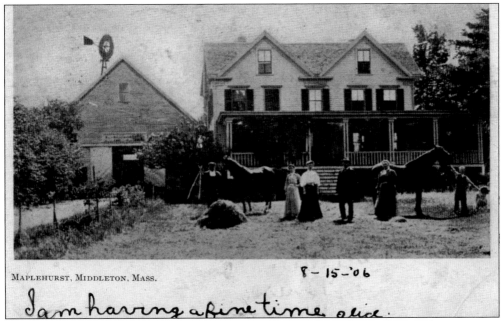

MAPLEHURST, MIDDLETON, MASS.

8 - 15 - '06

I am having a fine time. olid.

MAPLEHURST. Maplehurst was an inn in 1906. People came from the Boston area for one or two weeks of fine dining and fresh air. Throughout the years, it has also been known as Merrill's Boardinghouse, the Middleton Arms, Stonehenge, Log Bridge Inn, the Stephen James, Joe Binnette's Chalet, and is presently Angelica's Fine Restaurant and Function Hall.

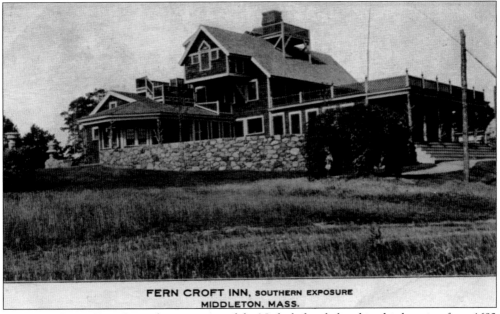

FERN CROFT INN, SOUTHERN EXPOSURE
MIDDLETON, MASS.

THE FERN CROFT INN. Several generations of the Nichols family lived in this location from 1692 to 1892. In 1893, it became the Fern Croft Inn. The original structure burned in 1911 but was rebuilt in the 1920s. It became a favorite place for several Boston politicians, such as Honey Fitz, grandfather of Pres. John F. Kennedy. Every comfort was provided—sumptuous dinners, a gambling establishment, horsemanship, lawn games, and "forbidden spirits" during Prohibition.

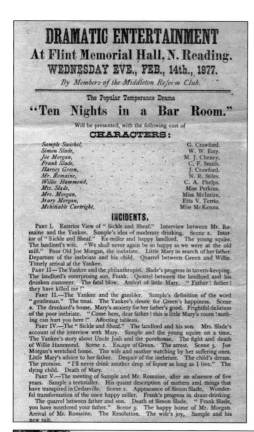

DRAMATIC ENTERTAINMENT
At Flint Memorial Hall, N. Reading.
WEDNESDAY EVE., FEB., 14th., 1877.
By Members of the Middleton Reform Club.

The Popular Temperance Drama
"Ten Nights in a Bar Room."

Will be presented, with the following cast of
CHARACTERS:

Sample Swichel,	G. Crawford.
Simon Slade,	W. W. Esty.
Joe Morgan,	M. J. Cheney.
Frank Slade,	C. F. Smith.
Harvey Green,	J. Crawford.
Mr. Romaine,	N. R. Stiles.
Willie Hammond,	C. A. Phelps.
Mrs. Slade,	Miss Perkins.
Mrs. Morgan,	Miss McIntire.
Mary Morgan,	Etta V. Terrio.
Mehitiable Cartright,	Miss McKenna.

INCIDENTS.

PART I. Exterior View of "Sickle and Sheaf." Interview between Mr. Romaine and the Yankee. Sample's idea of moderate drinking. Scene 2. Interior of "Sickle and Sheaf." Ex-miller and happy landlord. The young squire. The landlord's wife. "We shall never again be so happy as we were at the old mill." Poor Old Joe Morgan, the inebriate. Little Mary in search of her father. Departure of the inebriate and his child. Quarrel between Green and Willie. Timely arrival af the Yankee.

PART II.—The Yankee and the philanthropist. Slade's progress in tavern-keeping. The landlord's enterprising son, Frank. Quarrel between the landlord and his drunken customer. The fatal blow. Arrival of little Mary. "Father! father! they have killed me ?"

PART II.—The Yankee and the gambler. Sample's definition of the word "gentleman." The treat. The Yankee's desire for Green's happiness. Scene 2. The drunkard's home. Mary's anxiety for her father's good. Frightful delirium of the poor inebriate. "Come here, dear father ! this is little Mary's room ! nothing can hurt you here !" Affecting tableau.

PART IV.—The "Sickle and Sheaf." The landlord and his son. Mrs. Slade's account of the interview with Mary. Sample and the young squire on a time. The Yankee's story about Uncle Josh and the poorhouse. The fight and death of Willie Hammond. Scene 2. Escape of Green. The arrest. Scene 3. Joe Morgan's wretched home. The wife and mother watching by her suffering ones. Little Mary's advice to her father. Despair of the inebriate. The child's dream. The promise. "I'll never drink another drop of liquor as long as I live." The dying child. Death of Mary.

PART V.—The meeting of Sample and Mr. Romaine, after an absence of five years. Sample a teetotaller. His quaint description of matters and things that have transpired in Cedarville. Scene 2. Appearance of Simon Slade. Wonderful transformation of the once happy miller. Frank's progress in dram-drinking.

The quarrel between father and son. Death of Simon Slade. "Frank Slade, you have murdered your father." Scene 3. The happy home of Mr. Morgan. Arrival of Mr. Romaine. The Resolution. The wife's joy, Sample and his new suit.

TEMPERANCE ENTERTAINMENT. This is a flyer sponsored by the members of the Middleton Reform Club. On February 14, 1877, they performed a popular play for the public called *Ten Nights in a Bar Room.* Because of weather, it was unusual to have such entertainment at that time of the year. It must have provided a welcome respite from winter doldrums.

THUNDER BRIDGE. On East Street, Thunder Bridge, which spans the Ipswich River, is still a popular watering hole. It gets its name from the thunder-like sound it once made from the reverberations of wagons, cars, and trucks. It is a good place to begin a canoe journey down the Ipswich River, as it winds through Middleton, Topsfield, Wenham, and then through to Ipswich.

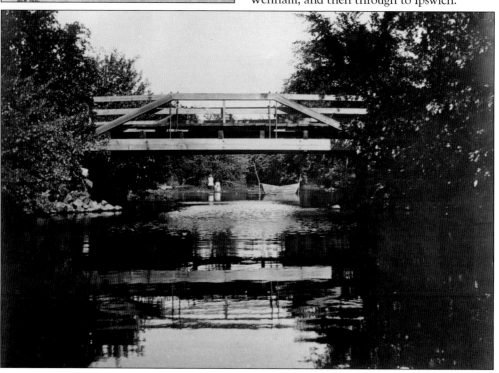

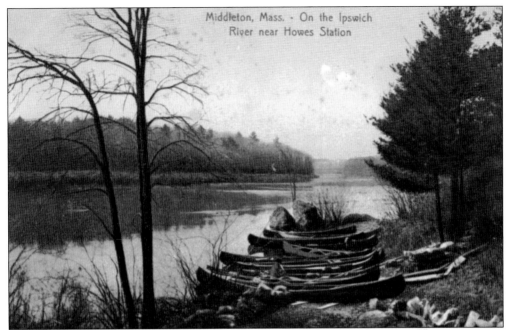

Middleton, Mass. - On the Ipswich
River near Howes Station

CANOEING ON THE IPSWICH. The first canoeists on the Ipswich were Native Americans, and the Ipswich was popular as a waterway. As people had more time and Middleton became a country resort town, it provided leisure sports. From the 1900s to World War II, several canoe rental businesses sprang up along the banks of the Ipswich. Blumberg's Canoe Rental on Perkins Road, pictured here, was one of the most popular.

FUN ON THE IPSWICH RIVER, 1917. Melintha Harriman, pictured in the front of the boat, lived on East Street near Thunder Bridge until 1930. She was a hard worker of little means who crocheted trim on union suits. Every Saturday, Melintha walked 4 miles to Howe's Station and took the trolley to North Salem, where she exchanged her finished goods. In winter she used a sled for her bundles and a cart in summer.

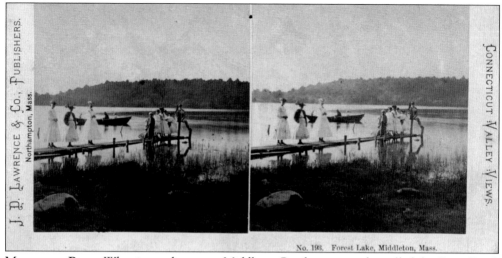

J. D. Lawrence & Co., Publishers. Northampton, Mass.

Connecticut Valley Views.

No. 198. Forest Lake, Middleton, Mass.

MIDDLETON POND. What is now known as Middleton Pond was once also called the Great Pond, Wilkin's Pond, Forest Pond, and Walnut Pond. This is a stereopticon view of Middleton Pond taken over 100 years ago. In the 1950s, boats were available for rent for 25¢ per hour or $1 per day. Since the 1950s, boats have not been allowed on the lake.

BEFORE THE DAM. This picture is of Ruby Ann Tyler at Middleton Pond before the construction of the dam, when freshwater clams were in abundance. In 1997, when water levels dropped during a great drought, fossilized specimens were seen for the first time in over 100 years. The normal water elevation was 85 to 88 feet, but in the great drought of 1997 it was only 75 feet.

THE PAVILION. The Pavilion was located on
Middleton Pond in Walnut Grove from the late
1800s to the 1930s. It provided a pleasant place
for picnicking, dancing, and drinking, especially
during the Prohibition era. Middleton town picnics
began at this location. Great bands played here,
including the Second Corps of Cadets. Fireworks
on the Fourth of July were shot over the pond. The
Pavilion was destroyed in the hurricane of 1938.

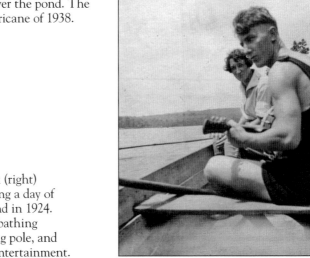

SERENADES WITH UKULELE. Frank (right)
and Sadie (left) Tisdell are enjoying a day of
fishing and fun on Middleton Pond in 1924.
Interesting to note is the woolen bathing
outfit sported by Frank, the fishing pole, and
accompaniment of a ukulele for entertainment.

MIDDLETON PINES. Located off Liberty Street was an area where camp lots were sold for $95, with $5 down and $1 per week, with a right-of-way to Mill Pond. Notice the formal camp clothes of the time. Other campgrounds in Middleton were on Kenney, Highland, Oak, and Perkins Roads, and River and Forest Streets. Billboards in Lynn advertised camp lots with a free pound of coffee given to buyers.

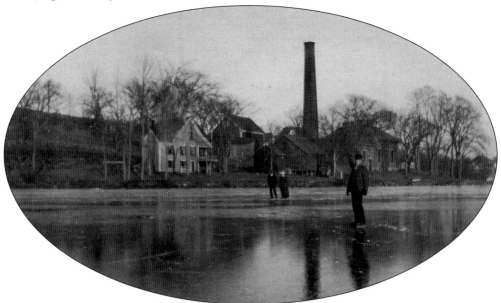

ICE-SKATING ON MIDDLETON POND. In the late 1890s and early 1900s, the pond became a favorite recreational spot for both winter and summer activities, including ice-skating, sleigh rides, horse trotting, swimming, fishing, and boating. Many businesses cut and stored ice in icehouses located on the pond. Ralph Currier had one of the first icehouses on Forest Street. Note the buckles on the skates that attached to shoes.

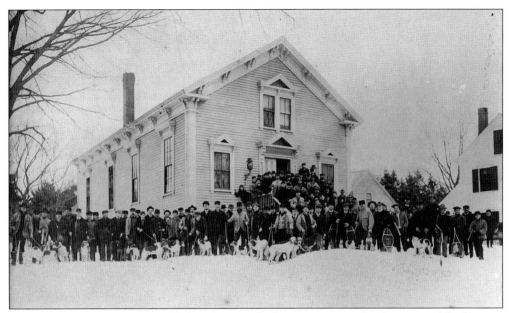

FOX HUNTS. Foxhunters assembled at the town hall in preparation for their annual fox hunt in the early 1920s, which was held only in winter. They broke up in teams so that all sections of the town were covered. Snowshoes were a necessity. Later they met at the town hall to warm up and share stories.

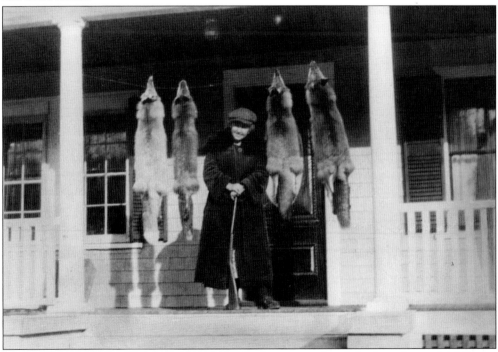

THE BEST SHOT. Alice Josephine Price Lee Mead was considered the best shot in Middleton. This photograph of her was taken in 1914 at the East Street home of the Lee family. Hunting and trapping in those days was an occupation that brought in a little currency for household needs that could not be purchased by bartering.

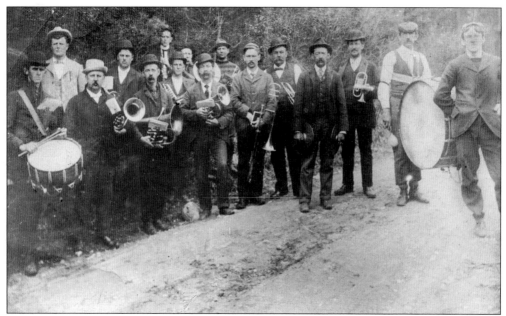

MIDDLETON BRASS BAND 1898. Local musicians entertained the community, playing for town picnics at Walnut Grove and at open-air concerts. A June 1899 concert had 3,000 to 4,000 people in attendance. On October 20, 1898, the Middleton Brass Band entertained along with Edison's Moving Pictures, which were silent movies the band provided background music for.

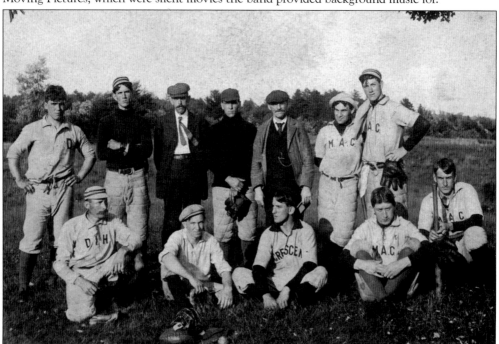

MIDDLETON ATHLETIC CLUB, 1906. Several athletic teams had sprung up by the early 1900s. Pastures and meadows in the 1900s were used for playing fields. Harry Huntoon is holding the bat. Hutchins, Hayward, Cronan, and Wilkins are the only other names listed on the original photograph.

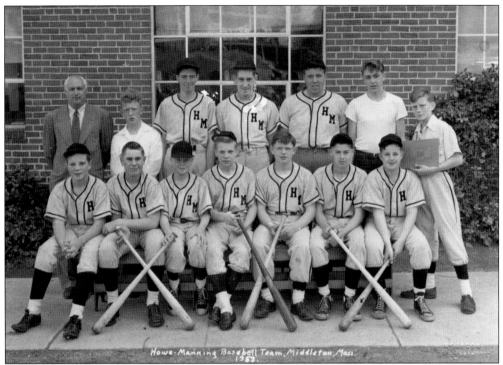

HOWE-MANNING BASEBALL TEAM, 1952. Middleton schoolchildren attended Howe-Manning School through the eighth grade. The team pictured here consisted of, from left to right, (first row) Roger Clay, Milton Pollock, James Coffin, Clifford Greeke, Roger Hubbard, Harold Pitman, and Edward Raynard; (second row) John Branch (eighth grade teacher and coach), Webster Morse, William Pitman, James Currier, Arthur Lohnes, Richard Sedler, and Bruce Tessier.

WALNUT PARK, C. 1920. Walnut Park was often confused with Walnut Grove. It was located on Webb Street behind the Congregational Church. This field was commonly referred to as the "bean ball park." Generations of Middleton folk remember scrub games here in the evening after work or on sunny afternoons.

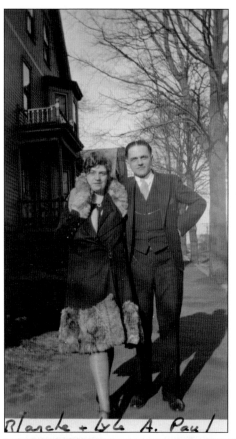

Blanche + Lyle A. Paul

NEWLYWEDS IN MIDDLETON. Lyle and Blanche Paul moved to Maple Street in Middleton in 1931. They were a devoted couple involved in town affairs. He was a hydrotherapist at the Danvers State Hospital, and she was a nurse at the same location. Many Middleton people were employed by the Danvers State Hospital or the Essex County Sanatorium.

THE MIDDLETON GRANGE, EARLY 1920s. The Grange, which represented rural America, was founded in 1867. Middleton's chapter met at the town hall. Residents gathered for educational events, dances, potluck suppers, rallies, and meetings sponsored by the Grange. This photograph is a meeting of the women at Bradstreet's house at King and Mount Vernon Streets, off Maple Street.

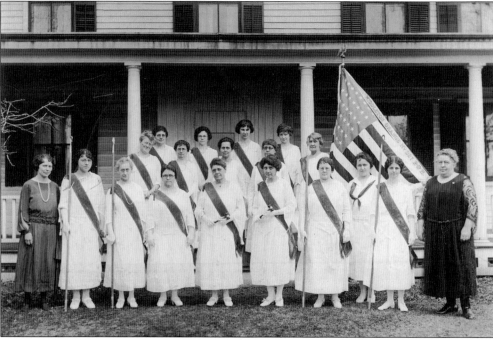

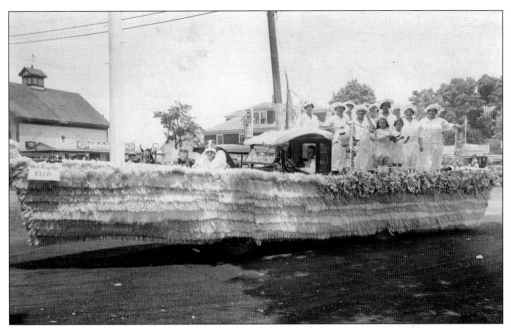

THE GET-TOGETHER CLUB. Here is a picture of the 200th (1728–1928) anniversary parade of Middleton. The Get-Together Club won first prize for this float. Entertainment was found among social, religious, and fraternal groups in town. As a result, the people worked closely together and formed lifelong friendships.

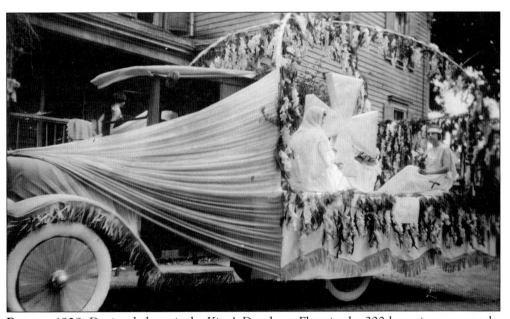

PARADE, 1928. Depicted above is the King's Daughters Float in the 200th anniversary parade. Elva Rogers Adams is seen here on the float. The King's Daughters were a well-known charitable group in Middleton. The King's Daughters chose the Danvers State Hospital and the Essex County Sanatorium as two of their main charitable causes.

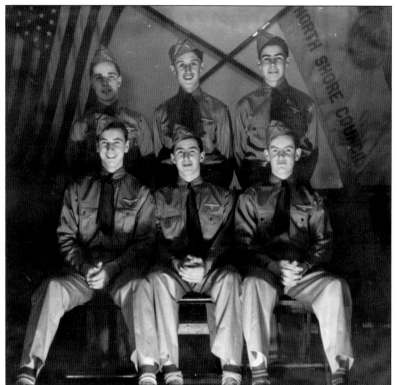

BOY SCOUTS, 1944. The Boy Scouts have been active in Middleton for over 45 years. Scouts in this photograph are, from left to right, (first row) Herb Ryer, Norman Gage, and Gordon Goodale; (second row) George Nash, Hugh Porter, and Al Godbout. Troop 19 is still very active in town today as more and more youngsters have joined. Langston "Lanky" Wall was the scoutmaster for over 20 years.

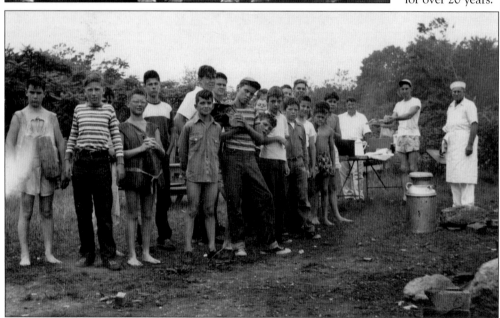

BOY SCOUT TROOP, 1951. In August 1951, Middleton Boy Scout Troop 19 went on Eddie Anderson's boat for a trip to Little Misery Island. On returning, there was a dense fog, and they were lost at sea. The Coast Guard was alerted when they did not return. The troop landed at Fisherman's Beach in Swampscott after a sleepless night. Scoutmaster Langston "Lanky" Wall, John Hilliard, Jim Ogden, and John Ross accompanied the boys.

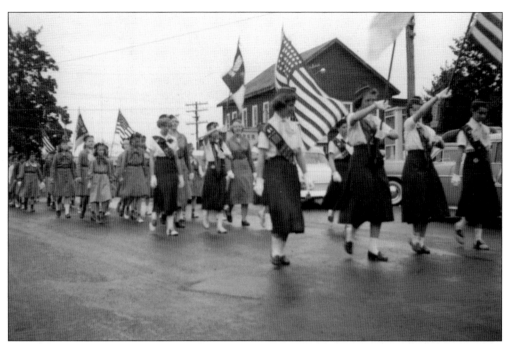

MEMORIAL DAY, 1957. Girl Scout Troop 81 was together from second grade until graduation from Masconomet High School in 1960. Leaders were Dorothy Coffin and Blanche Paul. It was common in those days for Girl Scout troops to stay together from the age of seven through high school.

MEMBERS OF BROWNIE TROOP 126. Friendships formed by these troop members were so close they still meet for reunions often, even in 2009. Seen here are Stephanie Seaver, Cathy Tyler, and Maryalice Brown. Other members of the troop were Jeanne Rubchinuk, Kathy Galeucia, Sally Fairbanks, Vickie Sutherland, Holly Gianino, Cindy Griggs, Jean Gaboriault, Kate Martin, Denne Leach, Suzanne LeBlanc, Judy McBride, and Elizabeth Cressey. The leaders were Kay Fairbanks, Joan Leach, and Shirley Paul.

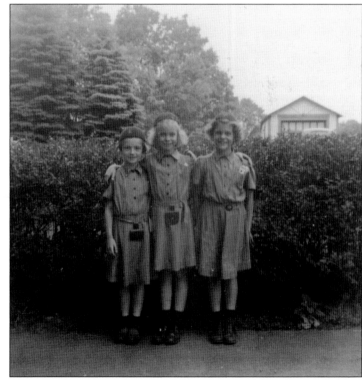

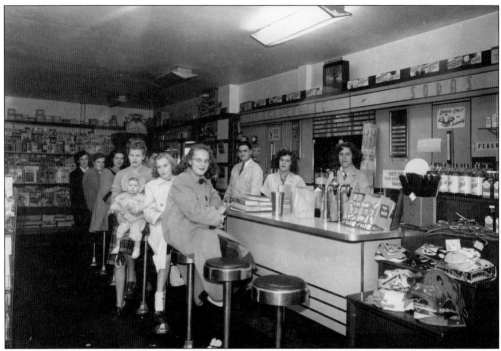

SOCIAL GATHERING SPOT. For several decades, Middleton Square Drug Store was the place for people to meet. Owners Jim and Ruth Martin employed many teens as soda jerks and counter assistants. The fountain served tonic, frappes, and 5¢ "beers," which were a combination of soda water, vanilla syrup, and coffee syrup. Dottie Frazier can be seen on the farthest stool.

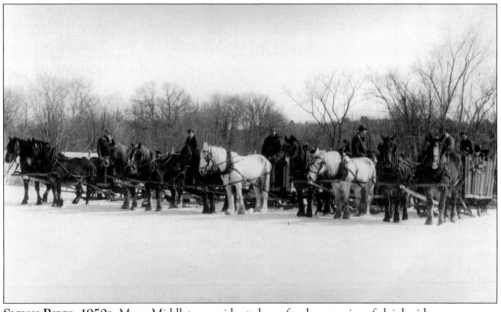

SLEIGH RIDES, 1950s. Many Middleton residents have fond memories of sleigh rides over snowy fields and lanes. Snow permitting, Warren "Tooty" Evans ran two rides a week. Hayrides were also popular all year long on the back roads of Middleton. A hot cup of chocolate tasted fantastic at the end of the ride.

Four

YANKEE INGENUITY AND BUSINESS

Most families farmed for their daily bread, but farmers who produced more than they needed were able to make a slight monetary gain. The Wilkins family and others were mill owners. The two most prominent types of mills in the 1700s through to the 1800s were sawmills and gristmills.

Another industry for Middleton was an ironworks that refined bog iron. Part of Middleton's earliest ironworks is preserved at the Smithsonian Institute in Washington, D.C., as an example of Yankee ingenuity.

Shoemaking was another industry that flourished in New England and Middleton and was a business that thrived mostly in the winter months. Dr. Silas Merriam and his son Francis P. were the first local manufacturer of shoes. Later the Merriam and Tyler shoe factory was located in Middleton Square.

Col. Francis Peabody founded the first box and paper mill in South Middleton in 1832. He was also a manufacturer of sperm whale oil and owned a refinery in Salem. Later the Crane family owned a paper company. In 1875, the E. J. Hickey Wallpaper Company made fine painted wallpapers at this location. The Bostik-Findley Company, which now occupies this site, manufactures adhesives in 2010. Josiah B. Thomas from Peabody constructed a large mill off Peabody Street on the Ipswich River that became the Thomas Box Mill in 1872.

In the late 1800s, J. H. Gregory owned more than 400 acres of farmland, where he developed the Gregory Seed Farm. Onion, squash, carrot, and tomato seeds were his specialty. Many of the homes he built for his workers are still standing on Gregory Street.

There were several icehouses operating on Middleton Pond in the 1800s and 1900s that provided ice. Housewives selected the size of the ice blocks by a placard placed in the window. The ice was carried on the iceman's back and placed in the icebox. Generations of children still remember the delectable cold chips he would pass out to them on his rounds. Refrigeration was not readily available to all Middleton homes until after World War II.

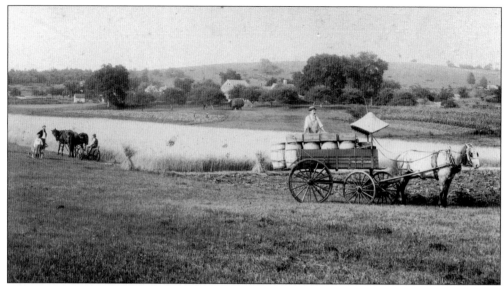

MIDDLETON COUNTRYSIDE, 1880s. Many farms were still in operation in the 1880s. This picture shows harvest time at the Deacon Edward Putnam's homestead on Gregory Street. What appears to be water in the background is actually a crop of rye, and what appears to be rocks are actually potatoes.

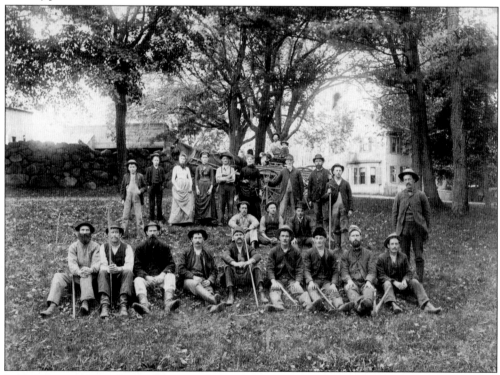

J. H. GREGORY SEED FARM. These workers are enjoying a rest for picture taking around 1870. Gregory was called the "Seed King," as his seeds were sold all over the world. The Gregory Seed Farm was located on Gregory Street off Maple Street. Max and Jennette Masi bought the last 40 acres (out of the original 5,400 acres) of the seed farm on Maple Street in 1940.

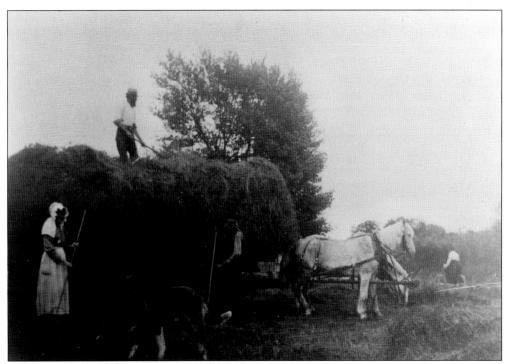

GETTING IN THE HAY, C. 1900. Folks worked all summer in preparation for the difficult wintertime. The photograph shows gathering the hay with the use of horses, wagons, and manual labor. Woman and children "pitched in" for this work. Many moonlight nights found families all working together to get the hay in before rain.

DAVID STILES HORSESHOEING BARN. The photograph of this Main Street barn was taken around December 1835. The blacksmith was a revered worker in agrarian times, and horseshoeing was a prominent business. Without his skills, horses could not work. In addition, blacksmiths were often the inventors of small tools and necessities.

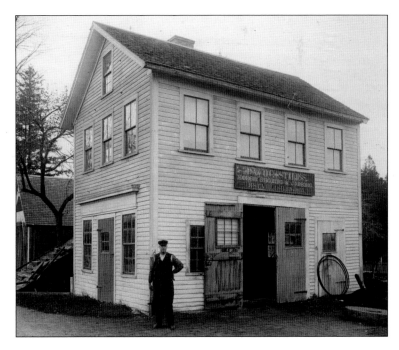

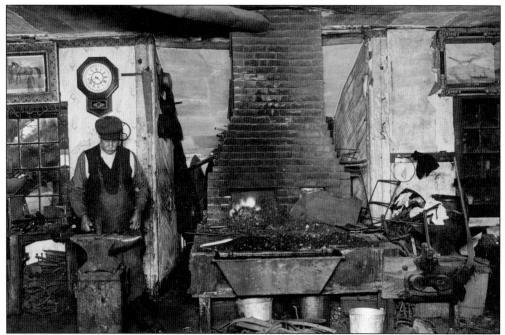

DAVID STILES BLACKSMITH SHOP. This was also a carriage shop. David Stiles was the inventor of a hay stalk cutter. It is hard to believe that the carriages were driven up to the second floor for repair. It must have been hot and dusty on some summer days. The clock in the background is now at the Lura Woodside Watkins Museum.

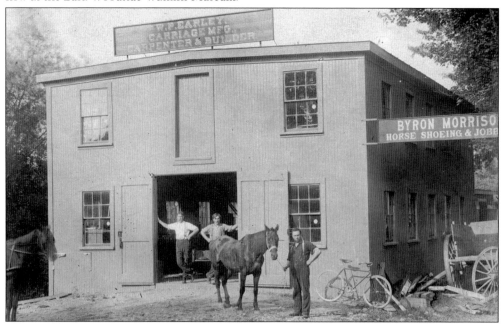

BYRON MORRISON SHOP. This blacksmith shop was located on South Main Street between Boston and Pleasant Streets. The shop was originally a gristmill and was located by a stream next to Middleton Pond. Later it became a garage and is still in evidence in Middleton Square. A convenience store, owned by Mike Patel, is presently in this location.

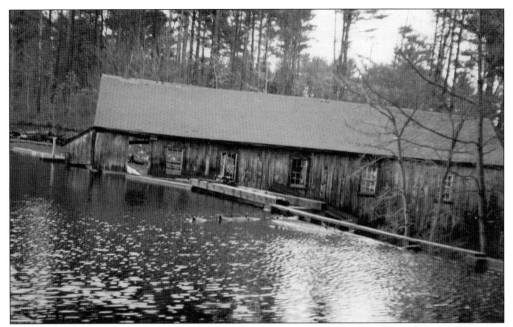

THE CURTIS SAWMILL. This photograph is of the Curtis Sawmill on Mill Pond, Peabody Street. Arthur Curtis worked with his brother Ernest at this mill until the mid-1900s. Timber was brought here to be milled and planed for the purpose of building many Middleton homes. Mill Pond was a quiet scene until the sawmill started its engines. Fire ravaged this building in the 1970s.

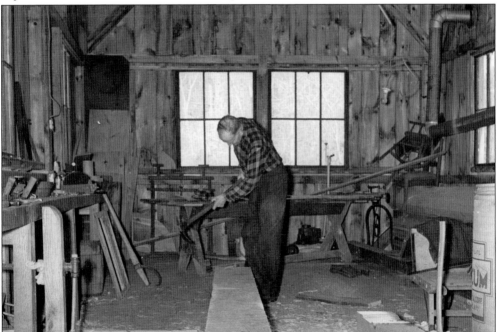

HAND-HEWN TIMBER. This photograph is of Arthur Curtis in the process of working wood in his mill. The Curtis brothers made beautiful pieces of furniture and other goods using only Middleton-grown wood. Many residents proudly own the Curtis brothers' handmade furniture and cabinets. Arthur was still working at the age of 90.

THE IRON WORKS BUILDING. The photograph shows the Iron Works Building on the edge of Mill Pond around 1940. The building housed the machinery and tools necessary to create bar iron. Locally mined bog iron was reduced to bars suitable for use by area blacksmiths. The iron works was in operation from 1708 to 1793 at this location. This building no longer stands.

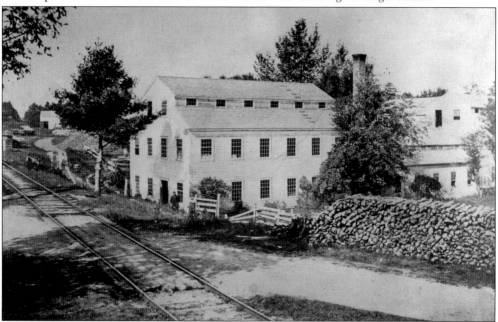

SOUTH MIDDLETON PAPER MILL. John Flint was the last of the Flint family to own the old Flint Mills on the Ipswich River. In 1832, he sold it to Col. Francis Peabody, who built his paper mill beside the old dam. In 1843, Luther Crane purchased it to make fine paper. On July 13, 1871, the paper mill burned. The site is currently occupied by the Bostik-Findley Corporation.

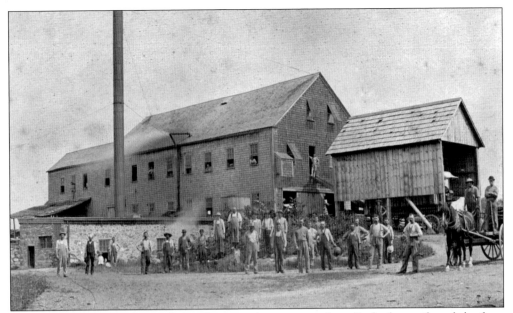

J. B. THOMAS BOX MILL. Josiah B. Thomas, a businessman from Peabody, purchased the farm of Samuel Symonds in 1872. He constructed the mill on the Ipswich River, off Peabody Street for the manufacture of wooden boxes. In 1892, on the afternoon of Christmas Eve, the Thomas Box Mill was destroyed by fire.

MAPLE RIDGE. Now occupied by the third and fourth generations of the James Coffin family, this house on Pleasant Street was once owned by Edward L. Rogers and was the first pharmacy in Middleton. In the 1940s, Dr. George Swett practiced dentistry here. The drill, operated by a foot pump, caused much fear to Middleton youngsters. Annabelle Sylvester, a local third grade teacher, gave piano lessons in this house.

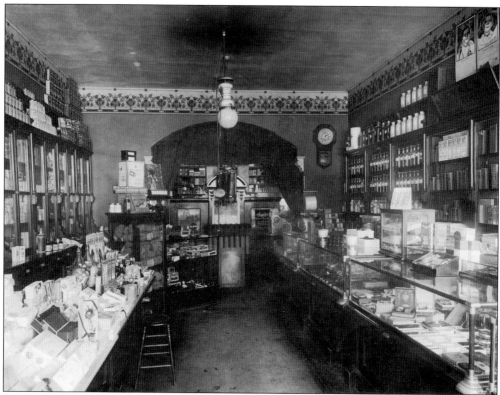

LINDLEY'S DRUG STORE. This photograph is of the original Lindley's Drug Store. Pharmacist John Lindley and family owned this store on the south side of North Main Street. He opened another store across the street, which became Middleton Square Drug. He ran this store until after World War II, when his son-in-law James K. Martin, also a pharmacist, and his son Bud Lindley assumed operation until 1993.

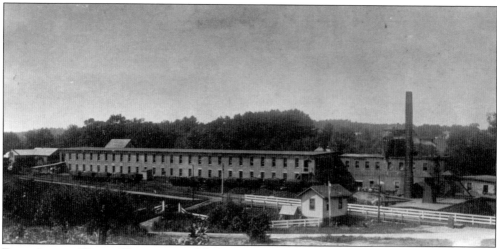

ESSEX ANILINE WORKS. This is a view of the Essex Aniline Works in the 1920s, which was the largest employer in Middleton at the time. The site was the location of the first Thomas Flint gristmill in the early 1700s. The Bostik-Findley Corporation is operating at this same location now. It remains one of the largest employers in Middleton.

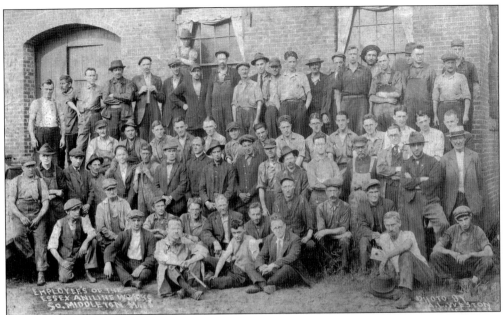

ESSEX ANILINE WORKS EMPLOYEES. The Essex Aniline Corporation, located at the Ipswich River off Boston Street in the 1920s, was a hide dyeing establishment. The Boston Blacking Company in 1928 followed them at the same site. The blacking was originally used for the old black stoves in people's homes. The B. B. Company later manufactured shoe polish and other chemicals at this same location.

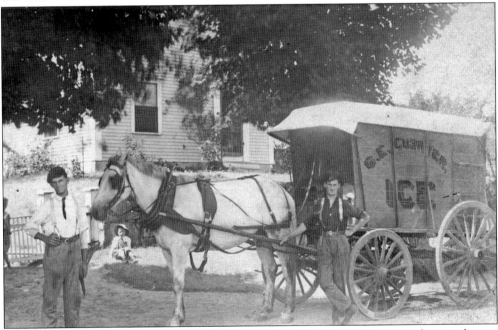

CURRIER ICE WAGON. The Currier family (Herb, left, and Ralph, right) operated two icehouses during the 1920s, one on Middleton Pond and one on Forest Street. This photograph is of the ice wagon making deliveries to homes and businesses, and it operated until after World War II. The Curriers maintained an ice business until the 1950s.

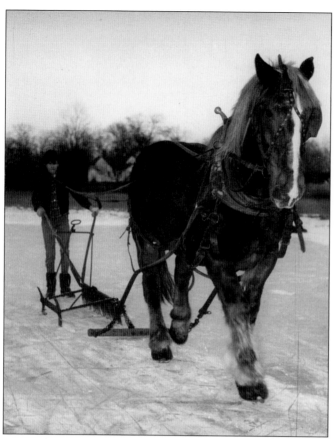

CUTTING ICE. In this photograph, Mark Currier is cutting ice off Peabody Street at the old Curtis brothers' farm located near the Ipswich River. Several shallow ponds iced up and made cutting ice a comparatively less dangerous operation than on deepwater ponds. The Currier family was in the ice business for several generations.

EMERSON SAWMILL. The Emerson Sawmill off Forest Street was operated by Darius Emerson, and later by his son Milton, from 1842 until the 1900s. The operation ceased when most of the local lumber was consumed. Some sawmills in Middleton continued until 1957. Oxen and horses were used for hauling.

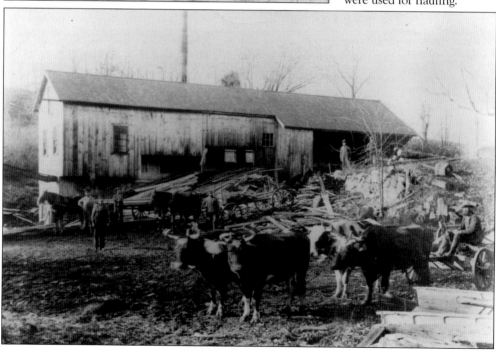

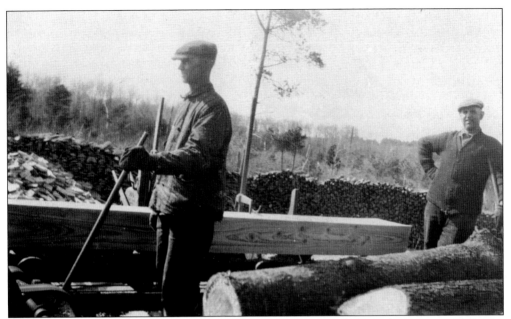

EMERSON SAWMILL CLOSE-UP. This picture shows Frank Evans (left) at the Emerson Mill. The other man is identified as a George Currier. Both were workers at the location. Other mills that operated close by included the Frazier sawmill on North Main Street. In Middleton, sawmills operated until the late 1950s.

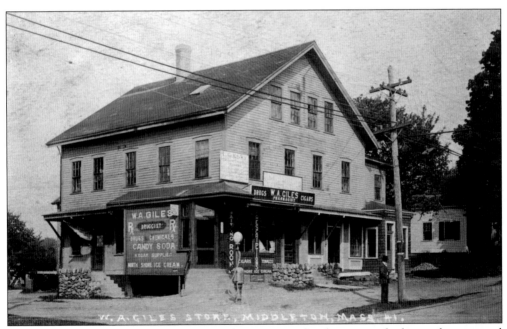

W. R. GILES STORE. Wayne Giles was the pharmacist at this drugstore, which was also a general store. Almost anything a housewife or farmer needed could be purchased here. A local butcher, Sidney Katz, was located in this same building on North Main Street in the 1940s.

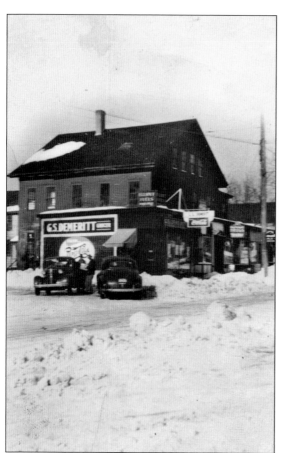

GRANVILLE S. DEMERITT'S STORE. The variety store was on the corner of Lake and North Main Streets in the mid-1900s. The pole with the white painted band denoted the bus stop of the Eastern Mass Bus Company. During World War II, Demeritt's Grocery was the only place to offer butter and sugar, which were closely rationed.

BRYER'S DINER. This diner on wheels was parked in Middleton Square blocking public parking in front of Demeritt's corner store in 1938. Bryer claimed to own this corner, which had been taken over for public parking. When he received his money from the town, Bryer moved the diner. The Middleton fire barn with its bell and cupola can be seen in the rear of this picture.

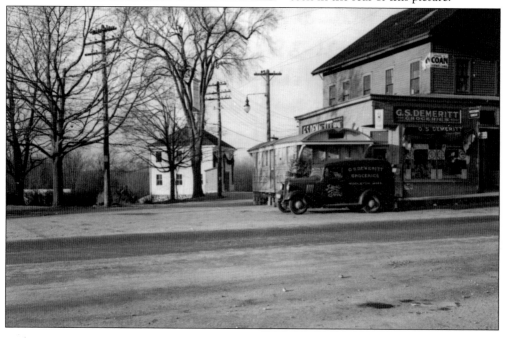

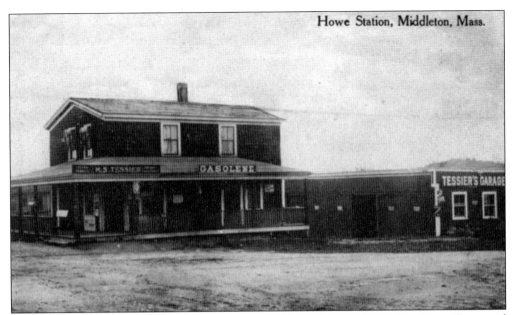

TESSIER'S STORE ON MAPLE STREET. A postcard of Howe Station shows the Tessier Store and filling station owned by M. S. Tessier, where provisions and gasoline could be purchased. Note the antiquated spelling of "gasolene" on the side of the building. The Eastern Railroad established a stop here called Howe's Station, which is now a convenience store.

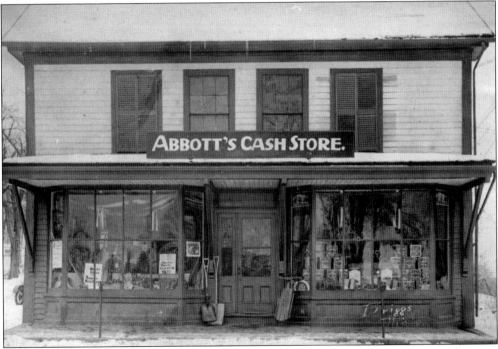

ABBOTT'S CASH STORE, 1923. The Abbott's store was located in Middleton Square on the same site where the Bluebell Restaurant later stood. Tonnelli's is located there now. The first Ford automobile agency was in back of Abbott's store in Wilkin's barn, which later became Middleton Square Drug and now houses the Reflective Design Company.

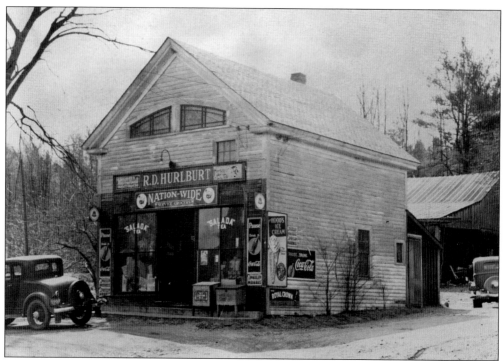

HURLBURT'S STORE. Rufus Delano Hurlburt from Yarmouth, Nova Scotia, ran this store for many years until the 1950s. This was a friendly neighborhood grocery store for northern Middleton and offered a public telephone. The building, located on North Main Street across from the entrance of Essex Street, is still standing.

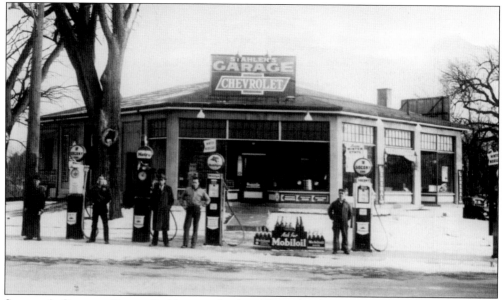

STAHLER'S GARAGE. George Stahler was the first Chevrolet dealer in Middleton. Pictured from left to right in front of his dealership are John Bishop, George Stahler, Harland Woods, and Chet Hood. The town dump was located behind Stahler's Garage. People were responsible for their own trash removal then as they are now.

SHOE SHOP. This shop was located on the Curtis farm on Peabody Street and was used by John Curtis in the late 1800s. It was common at this time for farmers to make shoes during the winter when crops were in. Both Arthur and Ernest Curtis learned shoemaking at the knees of their father, John Curtis.

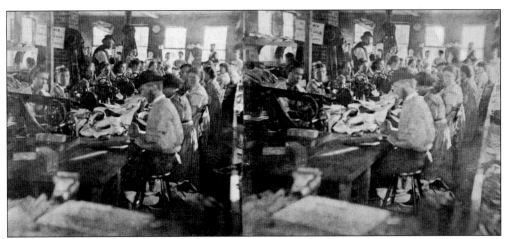

MERRIAM AND TYLER SHOE FACTORY. This is a stereoscopic picture of workers in the shoe factory located in Middleton Square in the late 1800s. The Merriam and Tyler Shoe Factory was the largest employer in Middleton at the time, and out-of-town workers came by train and trolley to work there. Note all the men wearing hats while at work.

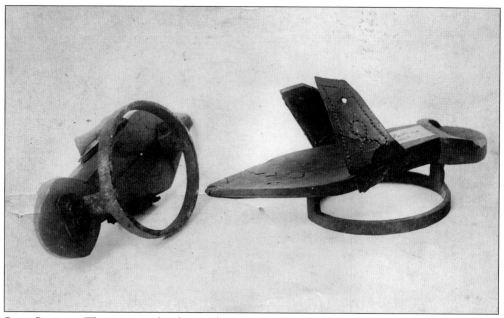

SHOE SAMPLES. This is a sample of some shoes produced at the Merriam and Tyler Shoe Factory. They could not have been very comfortable, but they kept the foot above the mud. Shoe samples were often referred to as patterns. Traveling salesmen took orders and delivered the goods throughout the Northeast.

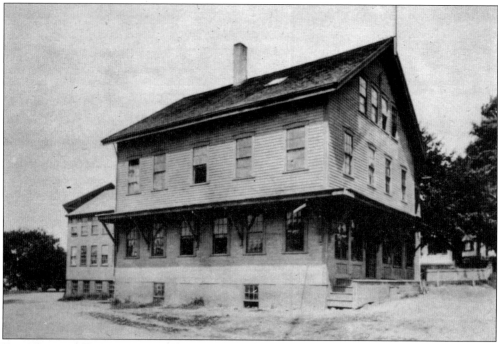

FIRST SYLVANIA PLANT, C. 1901. The original Bay State Lamp Company was in Middleton Square. It became the first Sylvania plant, which eventually became a multinational corporation. The business was located at the former Merriam and Tyler Shoe Factory building. Showrooms were on the second floor with long upholstered benches to sit on while trying on shoes.

FOUNDING FATHERS. The first Sylvania plant was located in the Merriam and Tyler Building, in Middleton Square. From left to right are Walter E. Poor (chairman of Sylvania in the 1940s), Edward J. Poor (a member of the family that pioneered Sylvania), and Frank A. Poor (who founded the company in 1901).

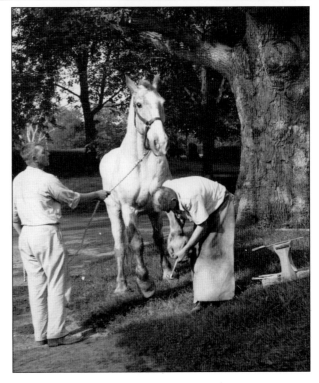

VISITING FARRIER. Here Richard Stowe (right) is shoeing Warren Evans's horse, King, under the Great Oak on Peabody Street. Warren Evans (left) was a well-known figure in Middleton, and he was responsible for promoting the history of farming and agriculture to many of the town's schoolchildren.

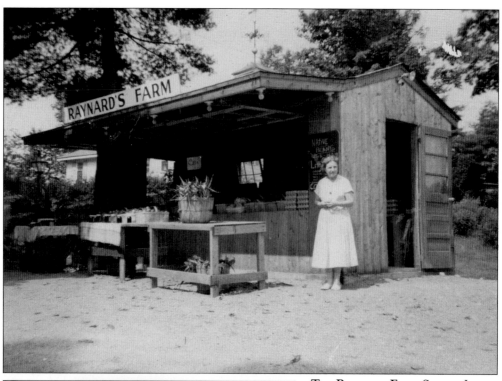

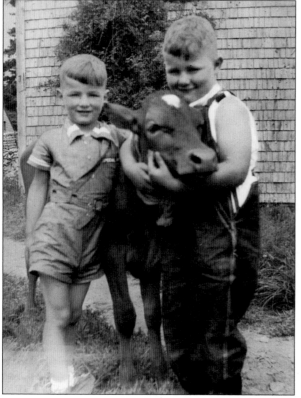

THE RAYNARD FARM STAND. Laura Raynard is shown standing in front of the family farm stand on Boston Street. Ralph and Laura Raynard and their sons—Ralph, Richard, and Edward—ran the stand from 1943 to 1974. They had an egg route conducted from an old Railway Express truck manned by Eddie Raynard during the 1940s and 1950s.

FARM CHORES. These two little farmers, Richard Raynard (left) and Ralph Raynard Jr. (right), are doing their chores on Boston Street in Middleton. The heifer was an important purchase for the family during the tough times of the Great Depression and also during World War II, when rationing was in effect. It was always difficult to eat the family pet.

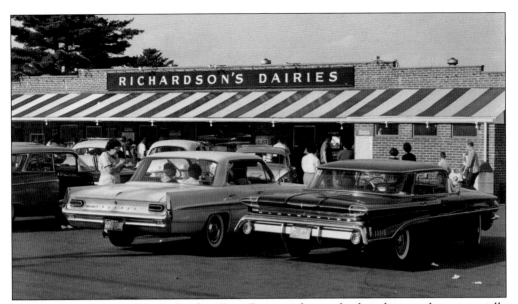

RICHARDSON'S DAIRIES. The Richardson Farm Dairies is famous for their dairy products, especially the delicious ice cream. The store above has been owned and operated by several generations of Richardsons. They have contributed generously to many good causes in Middleton. Hundreds of Middleton youngsters began their working careers here.

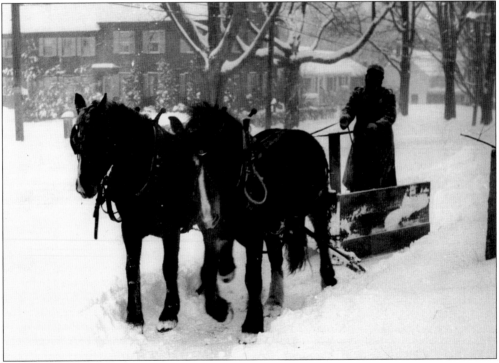

KING AND MABEL. Warren Evans is plowing the sidewalks on Maple Street with horses King and Mabel using a wooden plow on February 4, 1961. He also conducted sleigh and hay rides in Middleton for years. The Middleton Police Station, shown in rear, was the home and office of Police Chief James Wentworth.

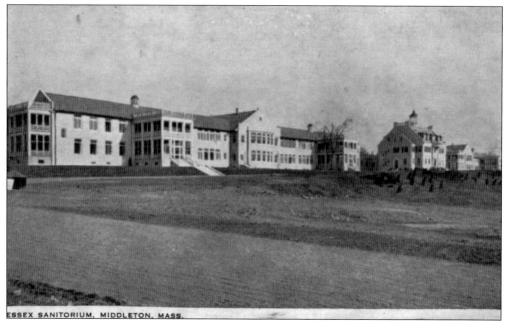

ESSEX SANITORIUM, MIDDLETON, MASS.

ESSEX SANATORIUM. After World War I, tuberculosis was rampant worldwide. Massachusetts mandated a sanatorium be built in each county. The Essex Sanatorium was built in 1928 as a state-of-the-art facility with a 350-bed capacity. After the introduction of antibiotics and new surgical techniques, the need for long hospitalization was reduced. The buildings were closed in 1964 and razed in 1976.

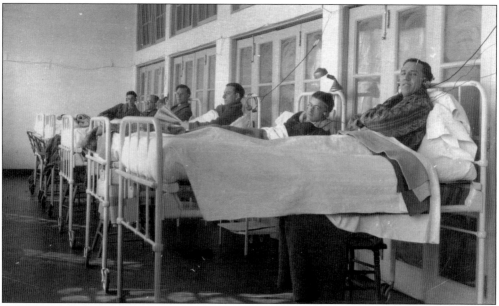

PATIENTS ON PORCH. Rest, fresh air, and good food were the only remedies for tuberculosis. This is the porch on the lower west ward. Patients slept in the open air, winter or summer, with no heat. Often snow would fall through the screens onto the patient's beds. Many Middleton residents devoted their careers to caring for these patients. Among the staff were Josephine Leary, Lloyd Getchell, Alice Regan, and married couple Lennart and Marie Winguist.

PATIENTS GATHERED ON LAWN. Standing in the back row of this 1924 picture are a lawyer, a banker, a student, a shoemaker, and a machinist—no one was immune from contracting tuberculosis. Kneeling in the front are sanatorium workers in white shirts. Many workers contracted tuberculosis and became patients themselves.

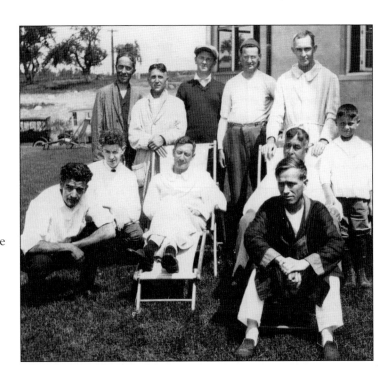

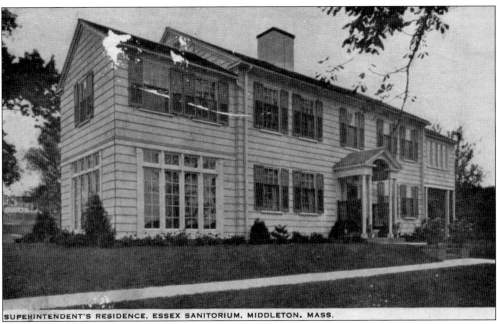

SUPERINTENDENT'S RESIDENCE, ESSEX SANITORIUM, MIDDLETON, MASS.

SUPERINTENDENT'S RESIDENCE. This was the residence of Dr. Olin S. Pettingill, a researcher and pioneer in tubercular medicine. Doctors and their families were obliged to live on the property of the Essex Sanatorium. One of the drawbacks of living on the property was that other children hesitated to visit, and the doctors' children were not always welcome in local homes due to fear of contracting tuberculosis.

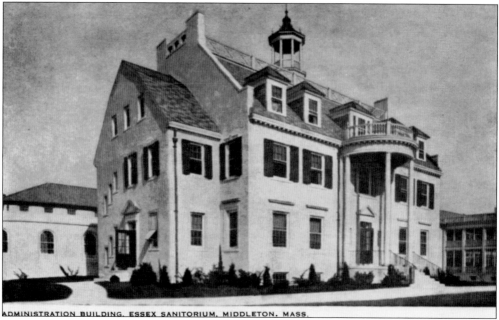

ADMINISTRATION BUILDING. ESSEX SANITORIUM. MIDDLETON. MASS.

ADMINISTRATION BUILDING. This building housed the offices, nurses' dining room, laboratory, X-ray room, main dining room, and staff and doctors' quarters. Waitresses and ward maids occupied the third floor. The staff was expected to live on-site unless they were married. All doctors were given housing for their families.

THE MUZICHUK BLOCK. Located in Middleton Square, these buildings housed a series of commercial enterprises over the years: the Merriam Leather Factory, the *Salem Evening News*, Sylvania, and several small commercial offices and stores. John Muzichuk completely changed the appearance of this block by removing the dilapidated eyesore of the old Merriam and Tyler Shoe Factory and constructing a modern brick office and retail building. The Muzichuk family has contributed a lot to the town of Middleton with several generations of service on civic and nonprofit boards and organizations.

BEWSHER REST HOME. This home at the corner of Kenney and Maple Streets was originally built in 1770 as the Andrew Perkins homestead. David S. Wilkins, a later owner, held many prayer meetings here in 1828. Rhoda O. Bewsher operated this house as a rest home, where she cared for many patients from the 1930s to the 1950s. It was later owned and renovated by John Deering, the first curator of the Middleton Historical Society Museum.

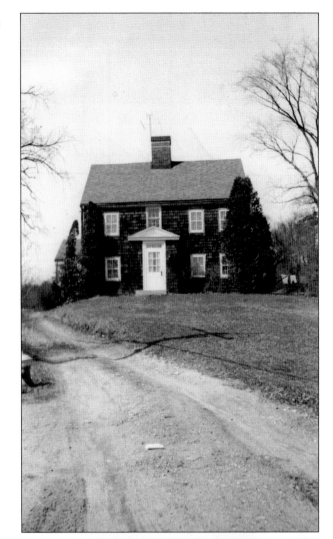

EVENTIDE REST HOME. This is a stereoscopic view of the home of Elisha Wilkins, built in 1842 and later owned by Henry A. Wilkins. Harold Purdy, chief of the all-volunteer fire department, bought the property in the 1930s with his wife, Dorothy. The couple converted it to a rest home and changed the name to the Purdy Rest Home. The site is now a municipal parking lot.

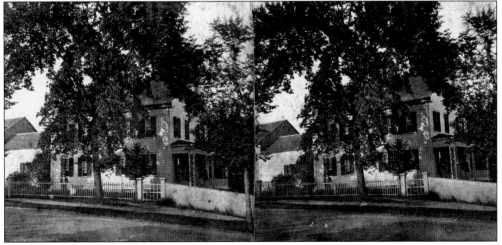

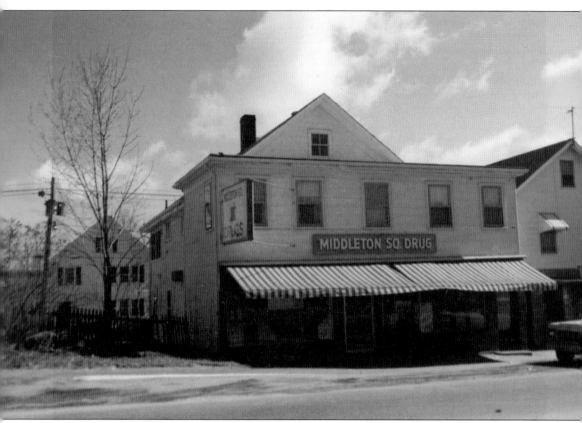

MIDDLETON SQUARE DRUG. John and Helen Lindley opened this drugstore after the old Wilkins barn had been converted from a horse stable to a Ford automobile agency and again to a modern pharmacy and general drugstore. The upstairs of the old barn was made into a large apartment for the family. After World War II, the Lindley's daughter Ruth and her husband, James K. Martin, a registered pharmacist, ran the drugstore. Anson "Bud" Lindley, John and Helen's son, also helped in the store after World War II. Both Jim Martin and Bud Lindley served in World War II with distinction. The Lindleys and the Martins never let anyone go without prescribed medication, even during the Great Depression. Jim Martin was also a volunteer fireman. When the fire whistle blew, both Jim and Fire Chief Harold Purdy, who owned Purdy Rest Home, would run across North Main Street and drive the first fire engine to the scene of the fire. Drugstore customers would simply have a cup of coffee at the soda fountain and wait for their return, or come back later. The Middleton Square Drug was an institution, the place to meet in Middleton Square for over 50 years. It was a sad day in Middleton on February 23, 1993, when the store closed. Ruth and Jim Martin helped organize the Middleton Board of Trade (MBOT) in the 1950s. The MBOT now has over 100 members, sponsors local businesses, and gives back to the community by supporting several activities in town, including the Pumpkin Festival, Chief Will's Day, and holiday street lighting. MBOT also sponsors two scholarships every year; the most recent were given in honor of Jim and Ruth Martin.

Five

THE PIOUS POPULACE

People of Middleton have long had the tradition of helping one another. Church members helped other church members regardless of denomination. The inhabitants of Middleton began constructing their meetinghouse in 1728, before the town was incorporated.

The first Congregational Church had to be authorized by the Provincial Massachusetts General Court. The inhabitants agreed to three conditions: supporting a building suitable for a meetinghouse, supporting a ministry, and establishing a school. A split in the congregation took place in the early 1830s between orthodox and evangelical observance of services in the church. Some 38 men formed a new evangelical church in 1832, and a new building was erected on 88 Maple Street on land purchased from Daniel Richardson for $61. The first meeting of the Middleton Evangelical Church took place on September 24, 1832, in a building that served the Evangelical Society for 28 years.

The remaining members of the First Congregational Church tried to hang on for several years but finally voted to tear down the church. Some of the congregation later organized as a Universalist Society and eventually built the Universalist Church on Boston Street in 1884. Until their new church was completed, the Universalist Society met first at the Centre School and then in the old town hall. The Universalist Church on Boston Street held their first service on November 5, 1886. The property later became a single-family home.

On South Main Street, the Methodist Episcopal Church was established in January 1881. This church only lasted for 26 years. It was sold in December 1907 and became a two-family house. St. Agnes Roman Catholic Church was built and dedicated in April 1948 on Boston Street on land donated by the Dennis Cronin family. In 1964, Rev. Richard Wilcox of Middleton Congregational Church and Rev. Paul Schmaruk of St. Agnes led Middleton's first ecumenical Thanksgiving service. The Thanksgiving eve observance has been held every year since. It is believed to be the first ecumenical service in the United States.

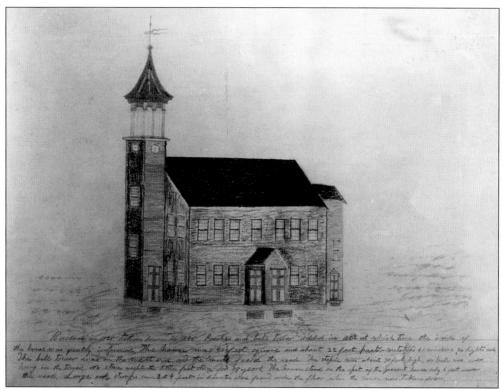

(handwritten text beneath drawing, largely illegible)

FIRST CONGREGATIONAL CHURCH. The church was built in 1726 to comply with Massachusetts law and originally faced west on Webb Street. Middleton was incorporated in 1728. In 1846, the church was taken down. This original meetinghouse stood on the same ground as the present Middleton Congregational Church.

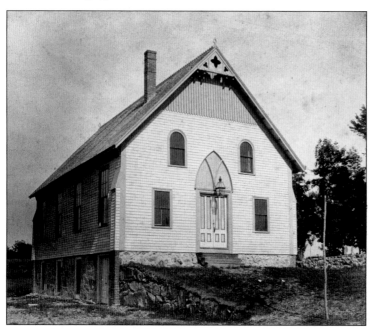

METHODIST EPISCOPAL CHURCH. This photograph shows the church located on South Main Street across from the intersection of Boston and South Main Streets. The church was dedicated on January 6, 1881. This church congregation was known for their love of music, and it was a lively place for 26 years.

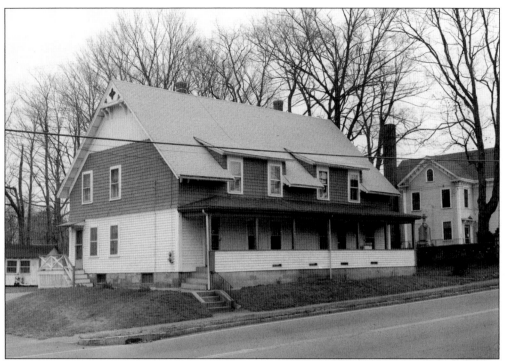

REMODELED METHODIST EPISCOPAL CHURCH. The Methodist Episcopal Church was sold in 1906 to Willoughby Early, who then proceeded to remodel it and turned it around to parallel South Main Street. It became a two-family dwelling. Oscar V. Johnson and his wife, Jenny, purchased the house in the 1920s. The wooden gingerbread trim is still seen today on the house.

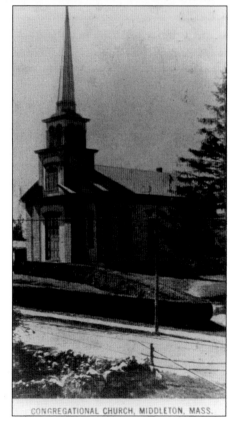

MIDDLETON CONGREGATIONAL CHURCH. This photograph depicts the church before 1933, when it was raised up 4 feet in order to house a vestry in the lower level. Note the hedges, the tall pine on the right, the carriage stalls located to the left of the church, the old stone walls and wooden fence, and unpaved Maple Street.

CONGREGATIONAL CHURCH, MIDDLETON, MASS.

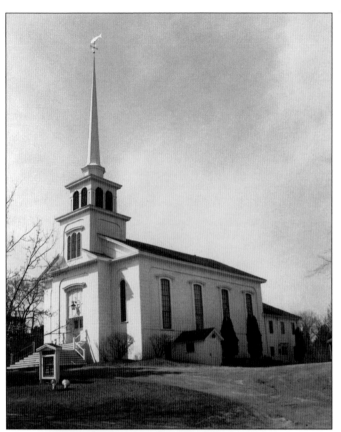

RAISED CHURCH. This is a view of the church after it was raised in 1933. The church was rebuilt and dedicated on November 30, 1859, and faced Maple Street. A large Sunday school was added to the rear of the church in the 1950s.

CHURCH PARSONAGE. Located on Pleasant Street, the church parsonage is shown in this photograph from around 1900. The parsonage housed the minister and his family and was often used for consultation and small church meetings. It is now a private dwelling. A new parsonage was built on Webb Street 70 years after this photograph was taken.

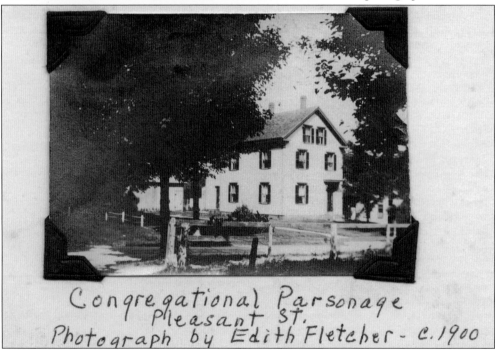

Congregational Parsonage
Pleasant St.
Photograph by Edith Fletcher - c.1900

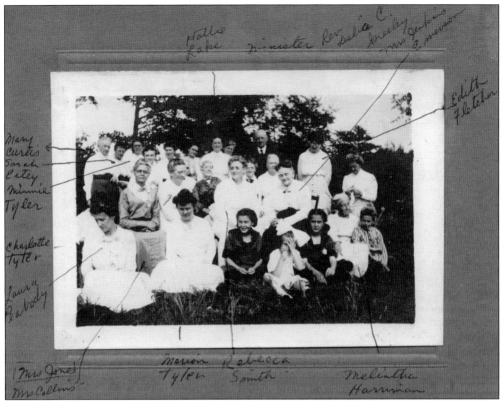

Handwritten annotations on photograph:
Hollie Lake — minister Rev. — Lelia C. Busby — Mr. Jenkins — Emerson — Edith Fletcher — Mary Curtis — Sarah Estey — Minnie Tyler — Charlotte Tyler — Laura Peabody — Mrs. Jones — Mr. Collins — Marion Tyler — Rebecca Smith — Melintha Harriman

DEACON'S PICNIC, C. 1915. The Middleton Congregational Church held a deacon's picnic every summer, and it was one of the highlights of the season. Everyone is dressed in their very best in spite of what must have been warm weather. Some familiar Middleton families represented in this photograph are the Tyler, Estey, Peabody, Collins, Jones, Harriman, Smith, Fletcher, Lake, Jenkins, and Emerson families.

ST. AGNES CHURCH. Dennis Cronan and his wife, Margaret Duffy Cronan, gave land for a Roman Catholic church in December 1936. On April 17, 1948, the dedication of St. Agnes Church, the only Roman Catholic church in Middleton, took place. Prior to this, Roman Catholics traveled to Danvers and later celebrated Mass at the town hall after the Danvers church became a mission church.

ST. AGNES CHURCH, 1950. This photograph was taken by Lillian Richardson in 1950, when Rev. John H. Quinlan was pastor. The St. Agnes Church has continued to grow since its dedication by Cardinal Cushing on April 17, 1948, and the Richardson family continues to be great supporters of the church.

ST. AGNES RECTORY. The archdiocese purchased the house in 1948 for $8,000. Attorney Raymond Sullivan of Danvers was instrumental in this acquisition and contributed a substantial sum to the project. Offices for church business and church counseling are in the rectory, and it still serves as a home for the priests of St. Agnes.

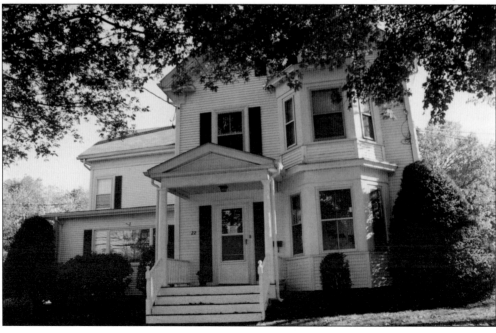

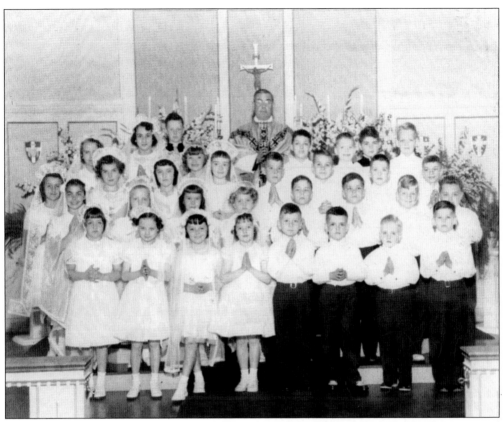

FIRST COMMUNION CLASS. Fr. John J. Quinlan and altar boy Philip Richardson (back row, second from left) are seen in this photograph of the First Communication class of 1950. The 1946 First Communion class officiated by Rev. James Welch included only two boys and 12 girls.

UNIVERSALIST CHURCH. Constructed in 1884 by members who had split from the Congregational Church in 1837, the building was sold in 1908 to Willis Esty of Brookline and became a private residence. There is no present-day evidence of the church, which was located at the beginning of Boston Street.

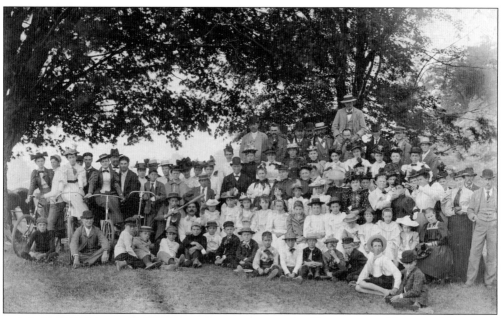

An Evangelical Meeting. These happy folk have enjoyed a sermon by Reverend Kincaid. The picture is taken about 1895 at Fuller Pond meadow off South Main Street. A lucky few owned bicycles. In spite of the sunny weather, no one is without a hat. Both men and women are dressed in what looks like formal attire but was probably just their Sunday best.

Olde Tyme Auction. This is an advertisement for an auction in the 1950s, sponsored by the Middleton Congregational Church, offering "a complete and interesting day" for all. A $1.99 ticket gained access to the auction of many types of things, from dishes to athletic gear, and was followed by a bean supper. Auctioneer Oscar Sheldon's daughter, Josie, married Milton Pollock, also an auctioneer, and both families were and continue to be prominent in the auction business.

Six

HISTORIC ABODES

The abundance of fresh, pure water, lovely groves and forests, magnificent vistas, the high elevation of the vast landscape, great quantities of choice lumber, and the abundance of open fields for cultivation made Middleton highly desirable as a place to settle and enjoy life. Because of the advantageous location, many beautiful homes were built in Middleton throughout the 17th–20th centuries and many remain to this day.

The William Nichols family settled in the northeast corner of town in 1651. Nichols was followed by Bray Wilkins, who located his home at the foot of Will's Hill by the "Great Lake," or Middleton Pond. The John Gingell family from Lynn settled near Wilkins. The fourth family to settle in Middleton was the Thomas Fuller family from Woburn in 1663. He was invited to settle by Wilkins and Gingell because he was a skilled blacksmith, a valuable trade at that time. Thomas Fuller had five sons who built houses in Middleton, and all five homes are still standing. Some Fuller descendants still reside in Middleton.

Many of the first founding families are still on the same land and even in the same home. The Middleton Historical Society has gathered together as many photographs of local historical homes as possible. They may be seen at the museum.

There was a substantial increase of population during the 1930s, when people moved from the cities to Middleton, converting their summer residences into year-round homes. Men could travel to Lynn via the railroads and automobiles to work at the two main employers of the area—United Shoe in Beverly and the General Electric plant in Lynn and Saugus. Although the town retained its rural setting for many years with slow growth of residents and very little growth of business, the population since 1960 has grown at a rapid pace. This growth changed the face of Middleton from a rural, agrarian community into a "commuter" community. In addition, the building of the Masconomet Regional Junior and Senior High School attracted many more residents to Middleton.

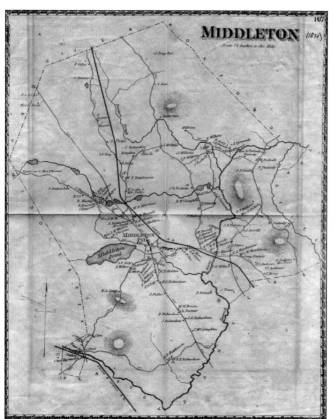

MAP OF MIDDLETON. This map from Beer's Atlas shows the location of Middleton homes and roads in 1872. Many of the homes on this map are included in this chapter. Some of these prominent families still reside in Middleton, and many of the old homesteads are still in use. The town grew slowly and steadily in population from 1728 to 1872.

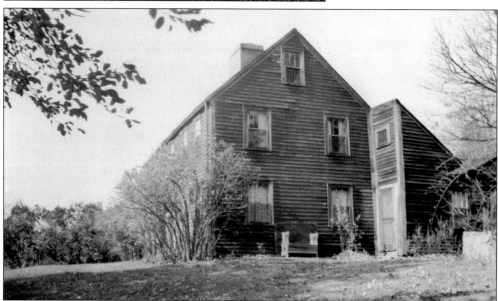

BRAY WILKINS HOMESTEAD. In the 17th century, Bray Wilkins Sr. was one of the first settlers in Middleton, which was then known as Will's Hill. His grandson Bray Wilkins built the farmhouse in 1703 when he wed. It stands on Mill Street to this day. Fortunately many generations have preserved the original stand of buildings on this site.

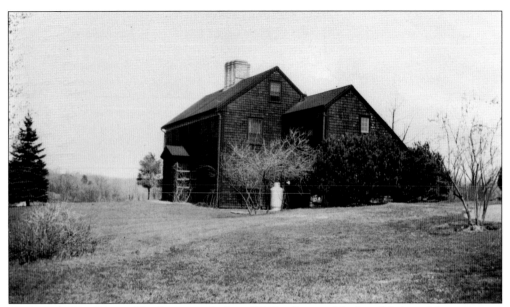

CHARLES B. JOPP HOME. This home was built in 1680 by Captain Hook in Salisbury, Massachusetts. It was moved in pieces to its present location on East Street in 1929 by Charles B. Jopp, Esquire. In 1954, Max Webber purchased the home and established an antiques business on the premises, where the Webber family still resides.

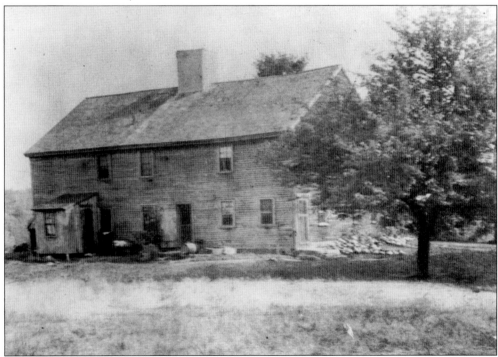

KENNEY-KING HOUSE. Located on Kenney Road, this house was built in the early 1700s by Daniel and Jonathan Kenney. Later Charles King and his family lived on the same property. The house was allowed to decay beyond repair and was demolished. Ray Farnsworth and family built a beautiful Colonial-style home on the same property.

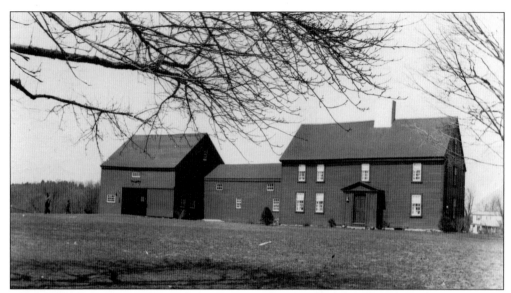

Deacon Edward Putnam Jr. House. Built in 1705, this home was originally only two rooms up and two down and is considered to be one of two 3/4 houses in Middleton. A 3/4 house was originally built with one room up and one room down anticipating an addition in the future. As can be seen in the picture, the addition was not balanced with the original building. It was built as a wedding gift from Edward Putnam Sr. to his son Deacon Edward Putnam Jr. Deacon Putnam was the first town clerk in Middleton in 1728. The house still stands on Gregory Street near Howe's Station.

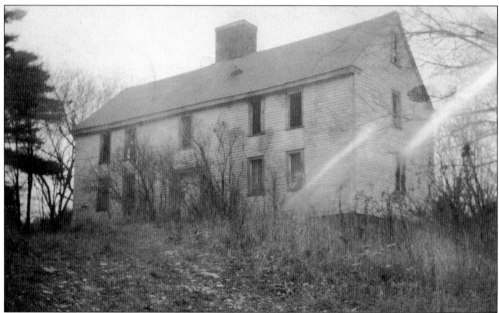

Hiram Stiles Homestead. The Hiram Stiles homestead, built in the 1700s, stands today near the North Andover town line on Essex Street. The Stiles family was prominent in Middleton for many generations. Hiram was active in community affairs and retained most of the agrarian property for many years. This home retains its classic lines thanks to loving restoration by several later owners, including Mary Jane Morrin, the present owner.

RUTH BERRY. This photograph is of Ruth Berry shown in her homemade clothing, which was typical of women's dress in 1905. She married the widower Hiram Stiles, son of Ebenezer Stiles, who was known for his singing. The family enjoyed performing on musical instruments, which were scarce in those days.

TIMOTHY PERKINS HOUSE. Built in the early 1700s, this house is located on Meadowbrook Farm Road where the Bampos family resides. Local legend has it that passersby on a Saturday evening can still enjoy the wonderful aroma of the molasses and baked beans once cooked there.

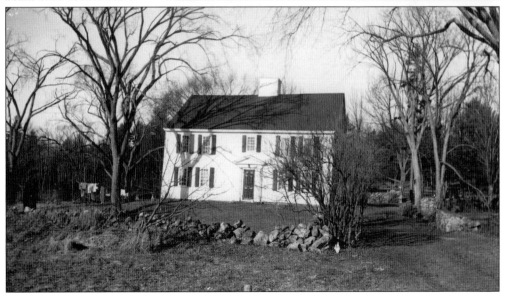

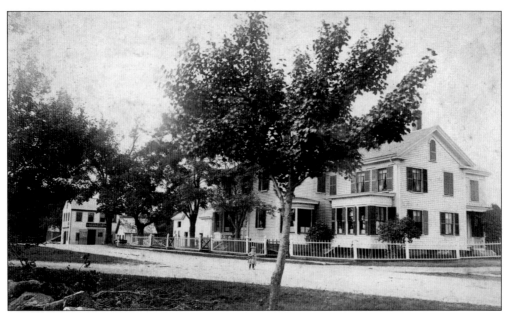

DAVID STILES HOMESTEAD. This homestead was a glorious stand of buildings at one time, located on Maple Street near the Middleton Congregational Church. It was the location of David Stiles's blacksmith shop and carriage factory. It was torn down in the 1930s.

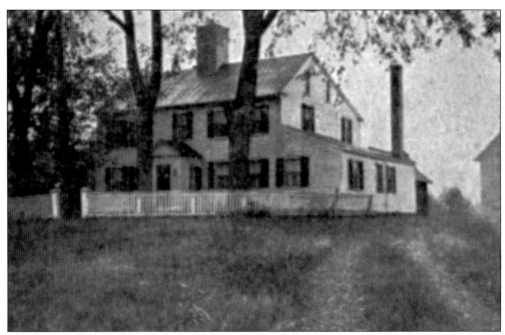

THE DANIEL FULLER HOUSE. This *c.* 1900 photograph shows the 1700s Daniel Fuller house on South Main Street. Daniel Fuller was a prominent businessman, active in many Middleton business affairs. He attained the title of esquire, which meant he could provide legal services to townspeople. In the late 1950s, the house was converted to an elegant restaurant.

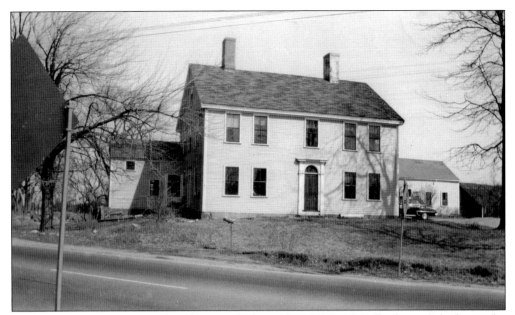

THE JACOB FULLER HOUSE. This photograph shows the 1714 Jacob Fuller house, which was the home of the Richardson family since 1855. Many additions were made to the original homestead. No longer the Richardson family home, it is used for commercial purposes. It is located on South Main Street.

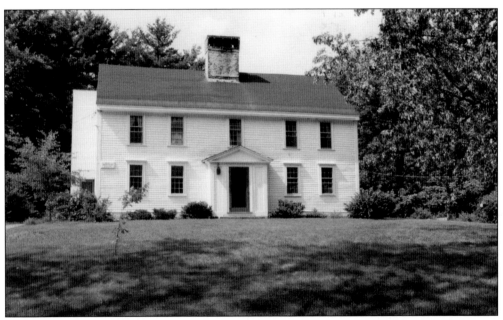

THE JOSEPH FULLER HOUSE. The Joseph Fuller house, shown in the 1920s, was built in 1714 and is still standing on Essex Street with its original Beverly Jog. A Beverly Jog is the term for what was another outside entrance to the home. This house is listed on the National Register of Historic Places as an example of first period architecture. Henry and Mary Tragert are the present owners.

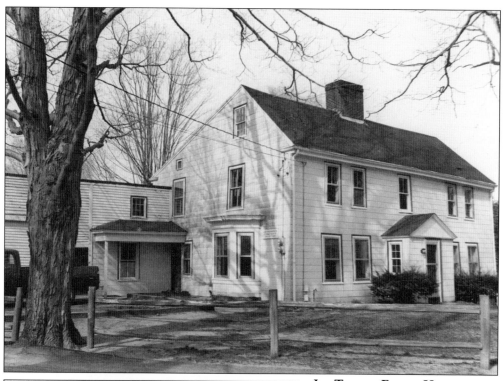

LT. THOMAS FULLER HOUSE.
This house, which faces south on Old South Main Street, is the earliest Fuller home now standing and was built in 1684. A small outbuilding remains where shoes were made in the 1800s. It abuts the old Fuller burying ground on King Street. The house is listed on the National Register of Historic Places.

GEORGE CURRIER. At left is a portrait of George Currier, who purchased the Thomas Fuller house for $1,300 on April 29, 1854. The Currier family owned and lived in the house from 1864 to the 1970s. William and Sally George, the current owners, have spent many years restoring this historical home. Sally George is the present town clerk of Middleton.

ALTHEA K. CURRIER. This photograph shows the daughter of Jeremiah and Hannah Richardson, who later became the wife of farmer and shoemaker George Currier. There are several branches of Richardsons who owned homes in Middleton in the 1800s. The Currier, Richardson, and Fuller families are still prominent in Middleton today.

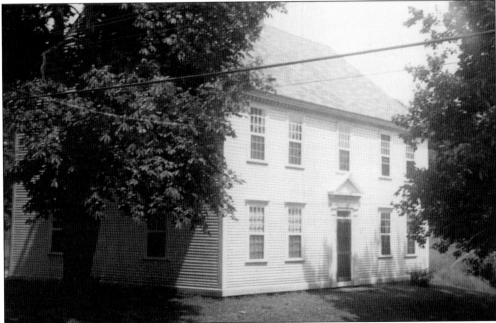

CAPT. ANDREW FULLER HOUSE. The house was built around 1750 on King Street by Samuel Bradford, a carpenter. He was well respected in the area for his skills as a woodworker and architect. Many architectural aspects of this home, both interior and exterior, resemble the details of the Estey Tavern, which was built in 1753 by the same carpenter.

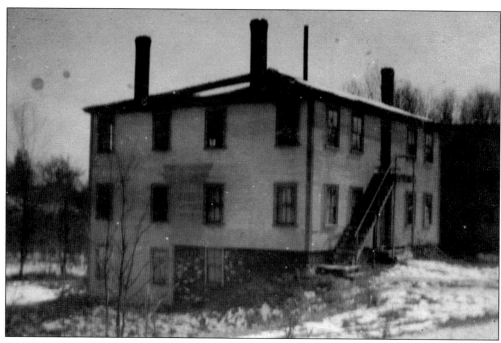

EPHRAIM FULLER HOUSE. This home was built by William Esty in 1810 on Middleton Square. It was removed to the east side of South Main Street below the square to make room for the building of the Flint Public Library in 1890. This house stands today as a multifamily dwelling and commercial site.

JOHN JAMES INGALLS. John James Ingalls was born in the Ephraim Fuller house. He served as a U.S. senator from Kansas for 18 years. Senator Ingalls was the featured speaker at the 1928 Middleton bicentennial celebration. His statue stands in the rotunda of the U.S. Capitol Building in Washington, D.C.

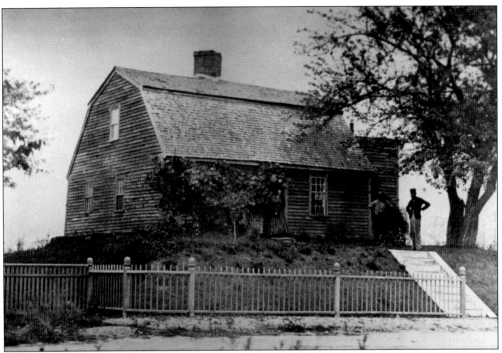

BAYLEY-BRADSTREET HOUSE. In 1713, Thomas Bayley built this home on the corner of Maple and Washington Streets, and it was owned by Rev. Andrew Peters in the 1750s. Abigail Bradstreet lived in this home for over 60 years. The Lura Woodside Watkins Museum on Pleasant Street used this home as its model for construction.

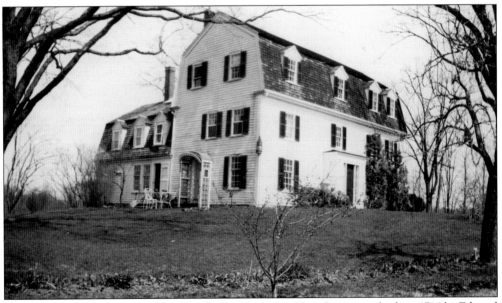

COL. BENJAMIN PEABODY HOUSE. This house located on East Street was built in 1714 by Edward Putnam Sr. and was purchased in the 1740s by Cornet Francis Peabody, father of Benjamin Peabody. Benjamin Peabody was a published poet and Revolutionary War hero at Ticonderoga, which later became West Point.

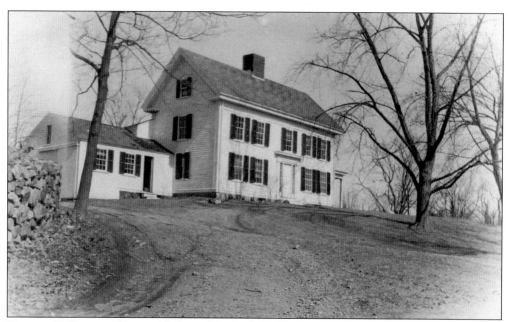

THOMAS C. PEABODY HOUSE. Nathaniel Peabody built this house around 1760 on Peabody Street for his son Thomas C. Peabody, who had a large shoe shop in the back of his property. The Great Oak of Middleton, thought to be over 400 years old, is seen across from the house. This later became the Curtis family home.

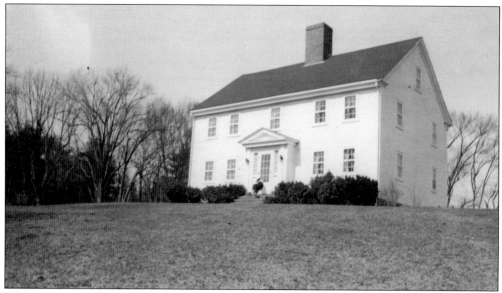

SAMUEL SIMONDS HOMESTEAD. Sometimes spelled Symonds, this homestead is located off Peabody Street near the Ipswich River. The homestead was later owned by Josiah B. Thomas in 1872. Thomas ran a box factory on this site. Still later this home was owned by George and Vivian Stahler, and then by Henry and Barbara Sawyer.

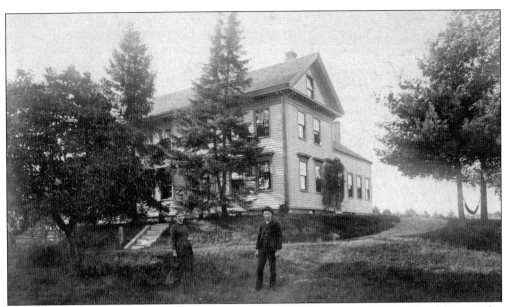

BENJAMIN HOWE HOME. This is the home of Benjamin and Ann Jane (Richardson) Howe, who lived here after their marriage around 1860. Pictured are Ann Jane and her son Galen in the late 1800s. Galen Howe later owned the Capt. Andrew Peters house on King Street. The house is now owned by the Magliozzi family.

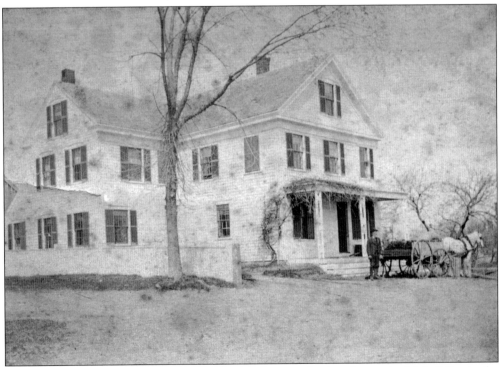

AVERILL HOUSE, C. 1883. A. A. Averill owned and operated a shoe factory in this building in the early 1850s. It is located on Maple Street next to the old town hall. It was considered one of the best locations in Middleton, with the Essex Railroad nearby and the trolley passing in the front.

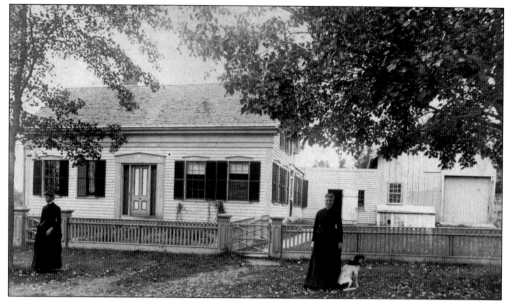

ELMER CAMPBELL HOME, 1850s. The former Campbell home still stands on Maple Street next to the original town hall. Built by J. H. Simmons, it was originally a story-and-a-half house and was later owned by Samuel Campbell and several generations of the Campbell family. There are several other photographs of this house at the museum.

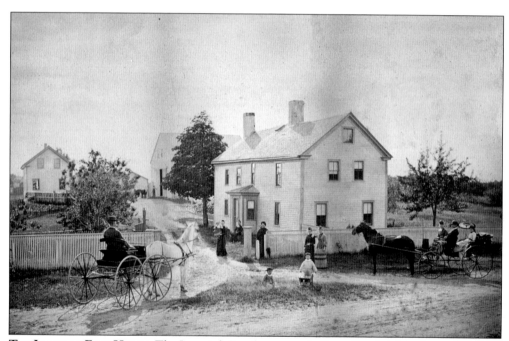

THE JEREMIAH ESTY HOUSE. The Jeremiah Esty house was built on South Main Street. He was a gentleman farmer who owned hundreds of acres of land. The home was occupied at different times by Abraham Sheldon and later by Jessie W. Peabody but no longer is standing. The photographer has staged this bucolic scene beautifully.

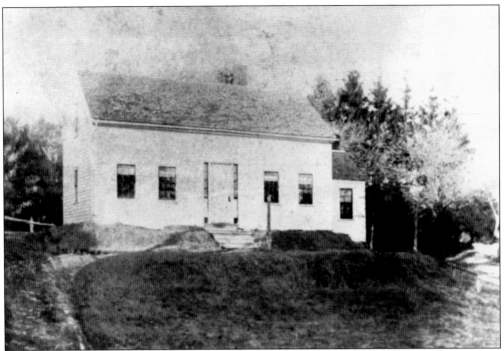

GEORGE E. GIFFORD HOUSE. The George Gifford family occupied this one-and-a-half story home, built in the mid-1800s, from 1909 to 1954. It is located on Maple Street between the old town hall and the Congregational Church. The Gifford family was involved with the Flint Library throughout the 1900s.

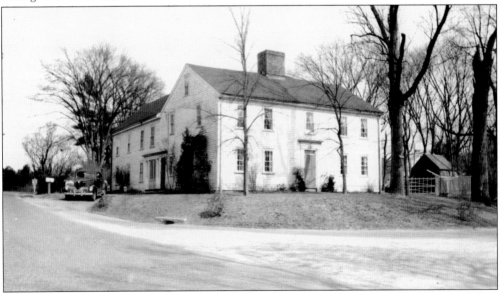

SAMUEL FLINT HOMESTEAD. Family history claims that this home was built in 1746 by Samuel Flint for his son John and his bride, Huldah Putnam. This house contained a store, a post office, and the first school in South Middleton. It was later home to Bertha Flint Woodward, the cofounder of the Middleton Historical Society Museum. The Flint homestead is now owned by Peter A. Madden Jr., a direct descendant of Samuel Flint.

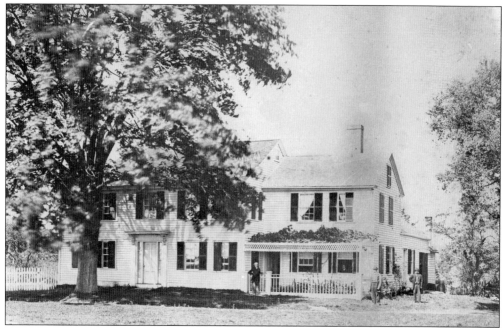

Lt. John Flint Homestead. This Flint homestead still stands on Elm Street. The original house was built in 1728 and has had several additions since that time. It is believed to be the birthplace of Charles Louis Flint, who donated $10,000 from his estate for the construction of the Flint Public Library in 1890. Three generations of the Sitomer family reside here now.

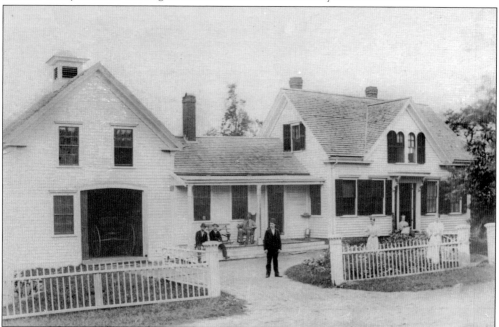

Huntoon House. Albert G. Huntoon was the highway surveyor in Middleton in the 1850s. He also ran a coal and wood business at this address on Lake Street. This photograph shows Huntoon seated on the left with his wife, Arley, standing in the front yard. Others in the picture are not identified. Seven generations of Huntoons lived in Middleton.

RUFUS DELANO HURLBURT HOUSE. Rufus and Beatrice Raynard Hurlburt purchased this home in 1912 after moving from Nova Scotia. The Hurlburts and their descendants lived in this house until the mid-1970s. The Hurlburts' daughter Addie and son-in-law Bill Witham were active in town affairs. Jack and Nancy Jones reside there now with their family.

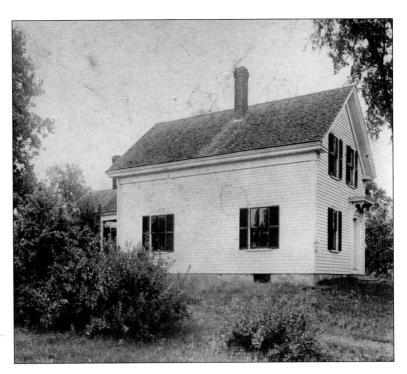

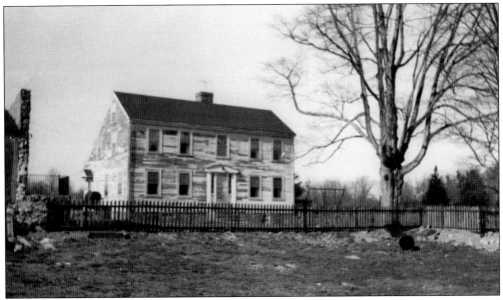

MASON HOUSE. Located on North Main Street near the Andover line, this house was occupied by the Mason family for over 200 years. The house has undergone many architectural changes in its more than 250 years and is a good example of an early saltbox-style home. The Muzichuk family has owned it for many years.

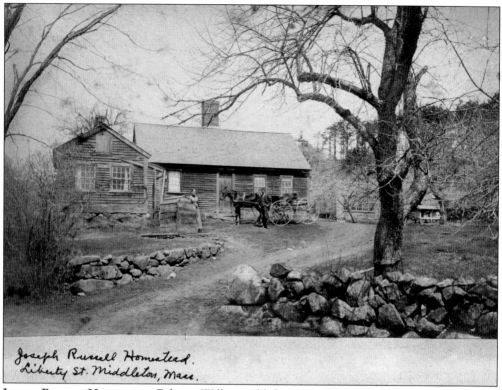

Joseph Russell Homestead.
Liberty St. Middleton, Mass.

JOSEPH RUSSELL HOMESTEAD. Ephram Wilkins sold the original house on this Liberty Street lot in 1825 to Joseph and Betsey Russell. The old house was replaced in 1886. J. Warren Russell and his wife, Elvira, are standing in front of the house near the elm tree planted by J. Warren Russell in 1857.

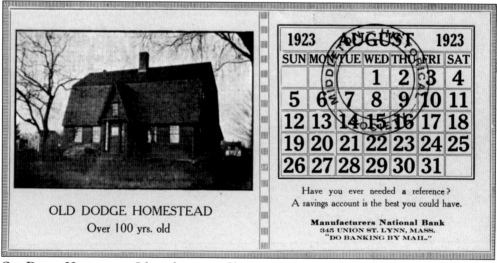

OLD DODGE HOMESTEAD
Over 100 yrs. old

1923		AUGUST			1923	
SUN	MON	TUE	WED	THU	FRI	SAT
			1	2	3	4
5	6	7	8	9	10	11
12	13	14	15	16	17	18
19	20	21	22	23	24	25
26	27	28	29	30	31	

Have you ever needed a reference?
A savings account is the best you could have.

Manufacturers National Bank
345 UNION ST. LYNN, MASS.
"DO BANKING BY MAIL."

OLD DODGE HOMESTEAD. Of wooden peg and beam construction, the Dodge homestead was built in the 1700s on South Main Street. In 1933, Irving "Chick" Adams and his wife, Elva, bought the homestead for $3,000 and resided there for 46 years. In recent years it has been remodeled and enlarged to serve as a doctor's office.

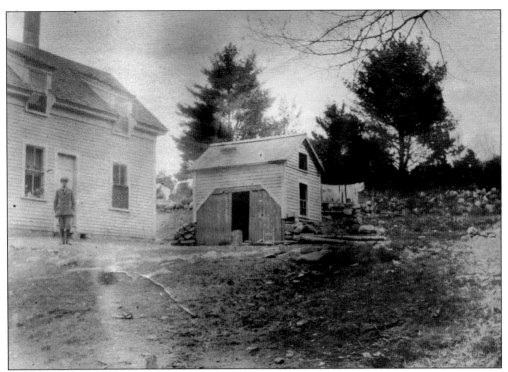

Frank Evans Homestead. Frank Evans stands in front of his home on Forest Street. His wife was Inez Currier. The Currier family is said to have lived in Middleton for 10 generations. At least three generations of Curriers reside on Forest Street today. Evans is said to have built this home himself.

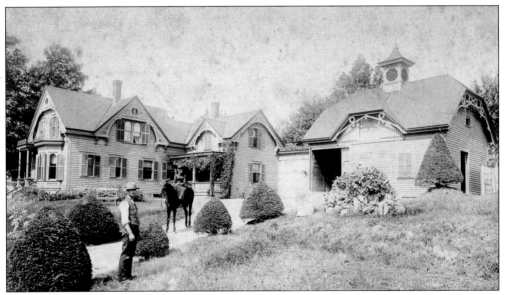

Ansel P. Tyler Homestead. The home of Ansel P. Tyler and his wife, Blanche, was built in the 1800s. He was a prosperous businessman and active in town affairs. The same organ he played for the Middleton Congregational Church was renovated many years later by his great-great-granddaughter Catherine Tyler Lindquist.

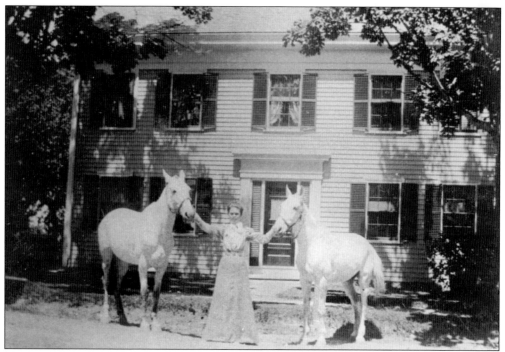

MAURICE TYLER HOME. Marion Tyler, daughter of Maurice Tyler, holds two horses in the front of her home on North Main Street in the 1900s. Maurice Tyler was active in town affairs; he was the town clerk in the 1920s. He cared for the streetlight over the watering trough in Middleton Square. He is said to have witnessed the arrival of the first train in Middleton in 1848 and saw the last train leave in 1926. This home is purported to have been used as a stopover for the Underground Railroad.

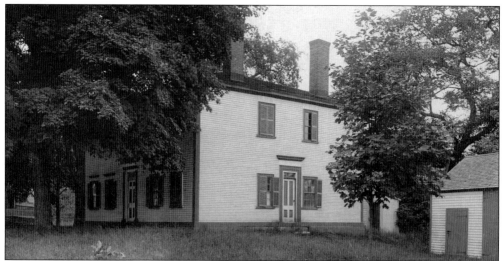

SILAS MERRIAM HOUSE. Dr. Silas Merriam built this house in Middleton Square in 1804. Dr. Merriam, who served as surgeon in the Revolutionary War, was captured by the British and later exchanged for British prisoners. Dr. Merriam also owned a gristmill on the stream coming from Middleton Pond. The house was moved in 1921 to its present location on South Main Street and is now a multifamily home.

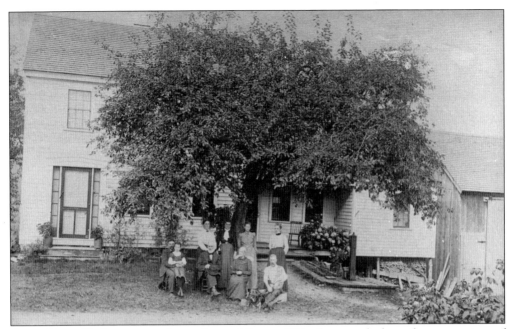

SOPER FARM. Eli Soper was a shoemaker and farmer. This photograph shows five generations of the Soper family at their home on Forest Street in the early 1900s. The Middleton Historical Society Museum exhibits a chair and tools used by Soper for the purpose of shoemaking. Some of the tools were handcrafted by family members.

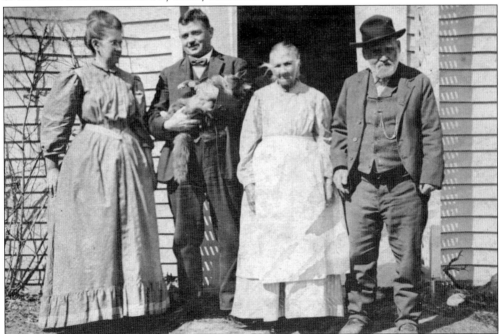

OGDEN FAMILY. Above is a portrait of the Ogdens at their homestead on School Street. Pictured are, from left to right, Elvira Perkins and James, Flora, and Benjamin Ogden. The family held prominent positions in town government and business, where they served the town of Middleton well. Several of their descendants still live in Middleton.

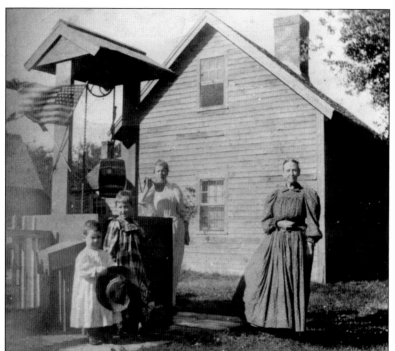

OLIVER WHITE HOUSE. This house on Maple Street was built by Oliver White in 1825. White was a shoemaker and this house is located near the Tramp House and Essex Railroad train stop. The American flag has 39 stars. There is an interesting fireplace on the second floor where shoes were made by Oliver and his family.

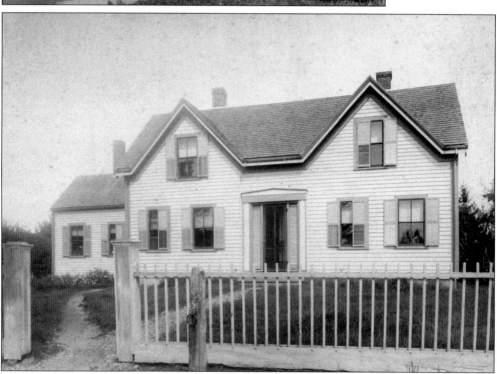

TUFTS-FLETCHER-JONES-HOUSE. This house on Maple Street was built in 1848 for Gustavus H. Tufts, and Samuel A. Fletcher later occupied it. Fletcher and his daughters Lillian and Edith all served as librarians at the Flint Public Library. The Jones family has now owned the house for several generations.

Seven

SCHOOL DAYS, SCHOOL DAYS, DEAR OLD GOLDEN RULE DAYS

The 1728 Middleton charter mandated the new town to provide for a schoolmaster to teach reading and writing. Nathanial Towne, the first teacher in Middleton, taught for over 10 years. At that time, teachers would board with various families, and each family paid towards the tuition. Mostly boys attended school during the winter session, when farm chores were fewer and the crops did not need attention. The very first schoolhouse was reportedly located on Maple Street near the Ipswich River in the 1700s. Other schools also sprang up on Liberty, Essex, South Main, East, and Boston Streets. Each district served an average of 40 homes.

A central school was built to house older students. Later the district schools were phased out and all the students went to the Centre School. The students who lived too far away were brought to school by a barge pulled by horses, which became a sleigh in winter. The original Centre School became the present Memorial Hall. In 1937, a new brick school was built on Central Street with the help of the Works Progress Administration (WPA). This school was named after two Middleton teachers: Alice Manning and Nellie Howe. The original 1937 Howe-Manning School had nine classrooms and 272 students.

Fuller Meadow School was built with 11 classrooms on South Main Street in 1972. The Masconomet Regional Junior and Senior High School, the first regional school project in the area, opened to students from Middleton, Boxford, and Topsfield in the fall of 1959. Prior to this, Middleton students went through the eighth grade at Howe-Manning School. The high school students were bused to Holten High School in Danvers from the 1920s to the fall of 1957 and then to Salem High School until the Masconomet School became available.

Education has always been of prime importance to Middleton citizens. The townspeople have supported their schools generously, as evidenced by the high percentage of tax dollars allocated to the education budget. A new elementary school for grades four, five, and six will soon replace the Howe-Manning School.

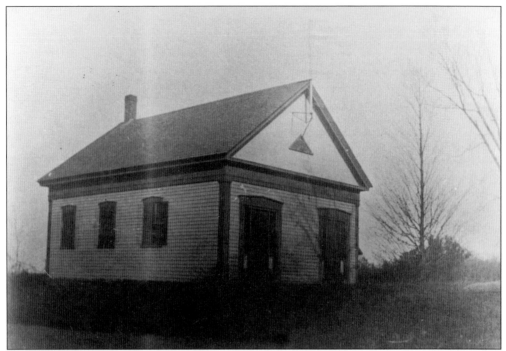

EAST DISTRICT SCHOOL. Above is a photograph of the East Side School, or East District School, on East Street in Middleton around 1900. Note the separate doors for boys and girls. Later the school became a private residence and was occupied by several generations of the Ogden family.

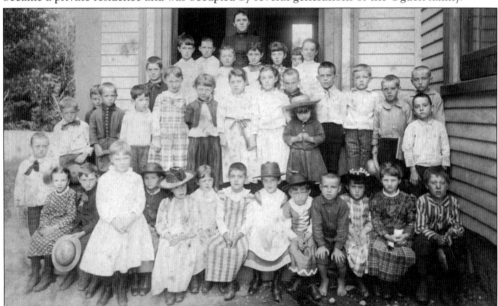

CENTRE SCHOOL, CLASS OF 1891. The Centre School (grades 1–12) was so called because the school system now encompassed all the other small district schools into one centralized school. This 1891 photograph was taken in Nellie Howe's first year of teaching. Howe was the only teacher of these 40 active pupils in a classroom that included several grades. Note the shoeless child in the front row.

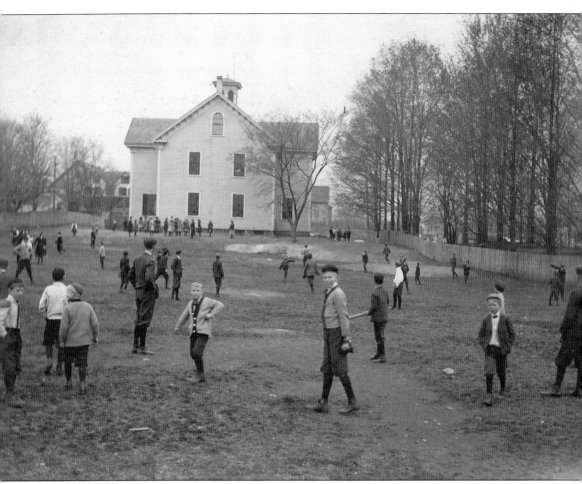

CENTRE SCHOOL. The committee appointed to build a center school, comprised of Daniel Fuller, Stephen Richardson, and Jeremiah Flint, held their first meeting in the Estey Tavern on April 6, 1808. The committee chose to buy the lot of land opposite the corner of Boston and South Main Streets from Dr. Silas Merriam for $25. Two schoolhouses were built previously on this same lot. Both were torn down for being of "inadequate structure." Finally a third schoolhouse (which is still standing) was built and dedicated in 1860. James N. Merriam, appointed to oversee the construction of the Centre School, was obsessed with overcoming the "evil" of poor ventilation. He insisted on high ceilings, windows that opened from the bottom, and "Emerson ventilators" to protect the health of the schoolchildren. After 1860, the district schoolhouses were used only for primary grades. Students in upper schools all attended the Centre School regardless of where they lived. At first the children were brought to school by barges pulled by horses, and later by school buses. Seldom were there any students over the age of 15 in the early years of the Centre School primarily due to family duties and chores.

NELLIE C. HOWE. Howe was a beloved schoolteacher who began her career in Middleton in 1891. She was the sister of Deacon Galen Howe of King Street. Howe spent her entire teaching career in Middleton, first at the Centre School and then at the Howe-Manning School, which bears her name to this day.

CENTRE SCHOOL, CLASS OF 1900. This is a photograph of the first grades with teacher Alice C. Manning. Harley Tyler is in the first row, fourth from the right. The rest are unidentified. The museum has photographs of most all the classes at the Centre School and the Howe-Manning School.

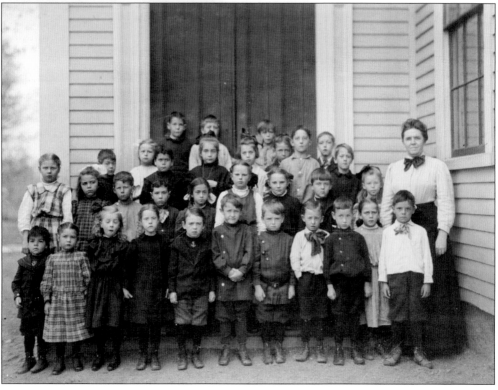

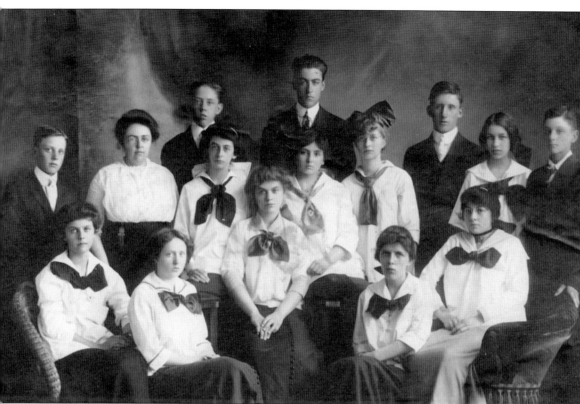

MIDDLETON GRAMMAR SCHOOL. The eighth grade graduating class of 1915 at the Centre School is pictured with teacher Alice Manning, who is second from left in the second row. Eighth grade graduations were a celebration and goal, as many of the students did not go on to high school. Uniforms were not worn to school, however this class certainly got the message of the attire Manning expected her students to wear for their graduation picture. Students in this class included Raymond Eaton, Ted Currier, Frank Quincy Currier, Raymond MacKenny, Grace MacDonald, Nellie Hudon, Olive Townsend, Marion Peabody, Guy Evans, Cecilia Kelley, Lucy Richie, Aldene Gardner, Margarete Kelly, Pearl Jones, Roger Phillip Boomhover, Anna May Porter, and Olive Frances Rowley. Three members of the class of 1915 were not present for the photograph. Manning began her teaching career in Middleton in 1903 and retired in 1951 as the principal of the Howe-Manning School, which bears her name.

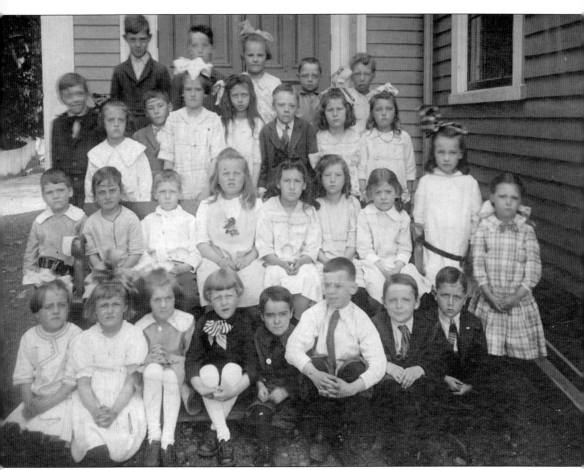

CLASS OF 1919. The photograph was donated to the museum many years ago by Helen Richardson Coughlin. She identified some the students in this picture as Catherine Martin, Dorothy Page, Alton Hubbard, Elwood Roberts, Edward Leary, Gordon Sheldon, Arthur Aiken, Priscilla Hastings, Flora Fournier, Eleanor Ewing, Myrtle Jones, Goldie Ogden, Harold Tyler, Jeannette Phaneuf, Helen Porter, Merton Punchard, Helen Richardson, Doris Osgood, Benjamin Ogden, William Ogden, and Gertrude Russell. The students were not necessarily all the same age or in the same grade in this photograph. On several occasions, students of different ages and grades were combined due to lack of space and/or lack of enough teachers. This photograph appears to have children of different ages in it. It is also unusual in that the teacher is not pictured with the students.

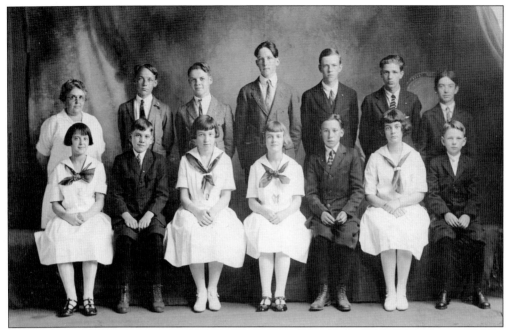

CLASS OF 1924. Eighth graders are shown here with their teacher, Alice Manning. Familiar family names still heard from this class include Sheldon, Martin, Gould, Abbe, Ogden, Jones, and Phaneuf. Note how many of the children in the class are taller than the petite Manning.

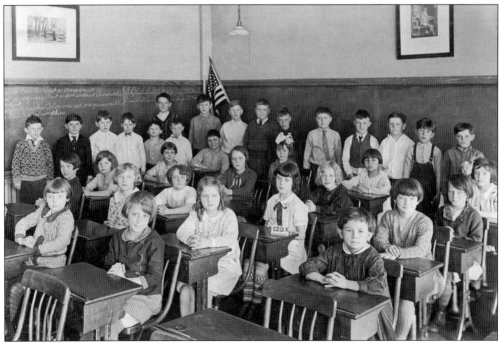

SECOND GRADE CLASS, 1927. This class is from the Centre School. Madelyn Lawrence was their classroom teacher. Familiar names include Bob Fuller, Parker Gifford, and Eleanor Hoezel (far right, first in row), who later became the mother of Frank Twiss, Middleton's present fire chief. Teachers were not allowed to be married if they wished to continue teaching.

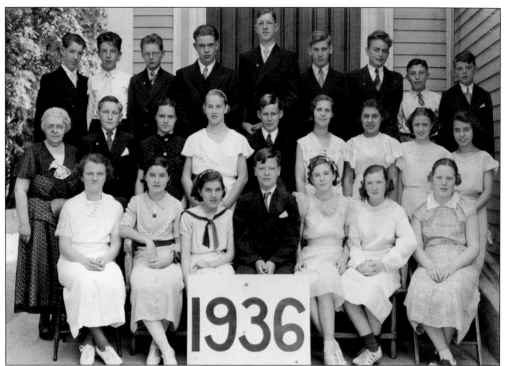

CLASS OF 1936. Alice Manning and her eighth grade class are shown in this photograph. The familiar names are Sheldon, Page, Adams, Paine, Currier, Richardson, Sanborn, Ballard, Wennerberg, and Donovan. Many students at this time did not go any further than the eighth grade.

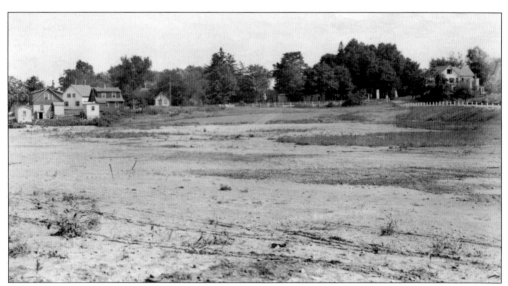

HOWE-MANNING SCHOOL. This photograph was taken from "The Pines" off Park Street. It shows the field as it was before the construction of the Howe-Manning School in 1936–1937. In the background are homes on Central Street. There were no houses on Park Street at the time, and the rural aspect of the area at that time is evident. The Pines is now a playground.

WPA PROJECT. This photograph taken from Park Street shows the construction of the Howe-Manning School. This was a Works Project Administration (WPA) project during the Great Depression of the 1930s. Many Middleton men and others from surrounding areas were employed on this school project. The school was built in just over one year.

HOWE-MANNING SCHOOL. This is a view of the school on Central Street as it looked in 1937. It had nine classrooms and 702 students in grades one through eight. Note the main entrance is on Park Street. The school was named for the dedicated teachers Nellie Howe and Alice Manning. The students from grades nine through 12 were bused to Holten High School in Danvers.

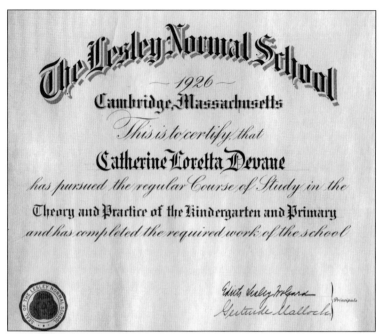

CATHERINE DEVANE. This is the 1926 diploma from Lesley Normal School in Cambridge of beloved teacher Catherine Devane. Many Middleton folks remember her with great fondness. There were no public kindergartens in those days, and she was everyone's first grade teacher.

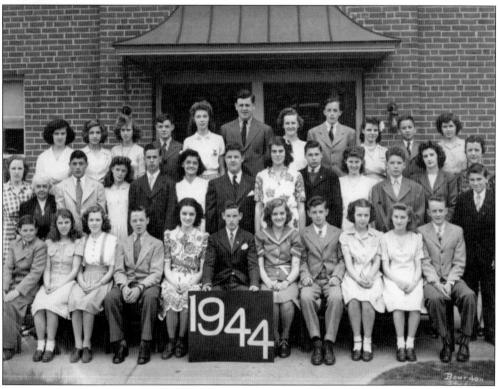

HOWE-MANNING, CLASS OF 1944. This photograph shows four teachers: Alice Manning, Ethel Mack, Ms. Keegan, and Madelyn Lawrence. Until after World War II, female teachers were required to be unmarried. Familiar family names in this photograph include Silvernail, Hurd, Coffin, Ogden, Osgood, Cass, Rubchinuk, and Bishop.

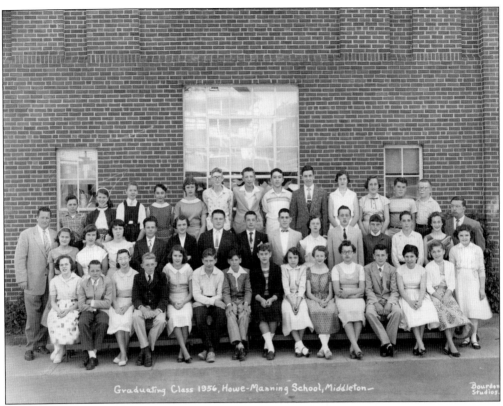

Graduating Class 1956, Howe-Manning School, Middleton—

Bourdon Studios.

HOWE-MANNING, CLASS OF 1956.
This class went on to Holten High
School in Danvers for their freshman
year, Salem High School in Salem for
their sophomore and junior years, and
became the first graduating class from
Masconomet Senior High School in
June 1960. However, a large percent
of the Middleton high school students
dropped out before graduating.

MASCONOMET DEDICATION PROGRAM.
Before the Masconomet Regional
High School was built, there was
no high school in the towns of
Boxford and Middleton. Topsfield
had its own academy, but it was too
small to be accredited. These three
towns were elated to be able to come
together to build a good school of
higher education for their students.

DEDICATION

MASCONOMET REGIONAL HIGH SCHOOL
ENDICOTT STREET BOXFORD, MASSACHUSETTS

MASCONOMET REGIONAL JUNIOR AND SENIOR HIGH SCHOOL. This September 1959 aerial photograph shows the Masconomet Regional Junior and Senior High School, located on Endicott Street in Boxford. Fortunately for Middleton students, farsighted school committee members gave of their time and energy in the planning, building, equipping, and staffing of the Regional High School. The school committee members were Rosamond L Bastable, Robert T. Sperry, and Richard E. Quinn, who also served as vice chairman. The first meeting of the school committees from all three towns—Middleton, Boxford, and Topsfield—was on February 7, 1956. The Middleton town meeting voted on construction of a six-year regional high school on October 1, 1956. The 38-acre property in Boxford was purchased from Mr. and Mrs. Frederick McComisky on July 1, 1957. Construction began on April 14, 1958. Julius Mueller became Masconomet's first superintendent/ principal on August 1, 1958. Masconomet's first official day was September 14, 1959, with 765 student enrolled. Middleton students were no longer "tenants-at-will" in the education system of nearby communities. The school is named for Masconomet, the sagamore (paramount chief) of the Agawams.

Eight

The Heart of the Community and Honorable Mention

The first free public library began in 1865, and books were housed in the old town hall with Samuel Fletcher as librarian. In 1879, the library was called the Middleton Library Association.

In his will, Charles L. Flint bequeathed the town of Middleton $10,000 to be used to build a public library. The town appropriated $3,500 more to purchase the Ephraim Fuller estate to make way for the library. The Fuller house was moved, and the Flint Public Library was built in a little over a year. It was dedicated on November 11, 1891. The first change to the structure occurred in 1980, when the coal bin and huge furnace were removed, and the cellar was converted to a senior center and a children's room. Always the "Heart of the Community," a renovated and enlarged Flint Public Library was dedicated in 2008, thanks to the overwhelming support of the townspeople of Middleton.

The police department has always done an exemplary and professional job keeping Middleton as safe and crime-free as possible. Simon Esty was the first constable in Middleton in 1860. The police chief, appointed in 1925, was also the fire chief. In 1983, the present police station was purchased from the town of Danvers for $1 and moved to Middleton. Since 1945, there have been six police chiefs: Wilbur Rundlett Sr., James Wentworth, Edward Richardson, Robert T. Peachey Sr., Paul F. Armitage, and James DiGianvittorio.

The fire department has evolved from a group of volunteers who primarily fought forest fires to the present force of professionally trained full-time firemen. The fire department also operates the ambulance service. It would not be possible to thank the firefighters for all they have done for the town. The most recent fire chiefs were Harold Purdy, George Nash, Henry Michalski, David Leary, and Frank Twiss.

The first Middleton Post Office was located in the Estey Tavern in Middleton Square. Later Oscar Cram was the postmaster in an early one-story building adjacent to Central Street. The present post office was relocated to a new building on South Main Street in 1968.

Charles L. Flint. In 1879, Charles L. Flint gave the town of Middleton $1,000 to establish a separate reading room in the old town hall, staffed by a suitable librarian and to "purchase books of a character to meet the wants of all people in the town." Later he bequeathed $10,000 for a public library, which was named after him.

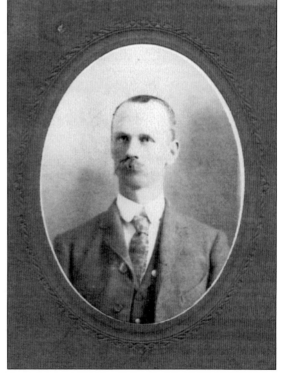

Benjamin Franklin Emerson. B. F. Emerson was born in Middleton in 1837 and made his fortune in the Gold Rush. He donated $10,000 to establish a fund to purchase books. Still in use today, it helps to supplement the library book budget. His cousin Ansel P. Tyler was one of the first trustees of the Flint Public Library.

FLINT PUBLIC LIBRARY DEDICATION.
The dedication service took place at the old town hall at 11:00 a.m. on November 11, 1891, a cloudy, rainy day. The address was given by the Honorable Charles J. Noyes of Boston and lasted over two hours. A dedicatory hymn was written for the occasion by Alice W. Merriam Moore.

DEDICATORY SERVICES

— OF THE —

FLINT PUBLIC LIBRARY.

Held at Town Hall, Middleton,

WEDNESDAY, NOVEMBER 11, 1891,

TWO O'CLOCK P.M.

LIBRARY OPEN FOR INSPECTION FROM 10 A.M., UNTIL 2 P.M.

FLINT PUBLIC LIBRARY. This 1891 photograph is one of the earliest of the Flint Public Library in Middleton. Notice that there is only one stained-glass window. The first stained-glass window was a gift of Caroline Fuller Smith in memory of her father, Jesse Fuller.

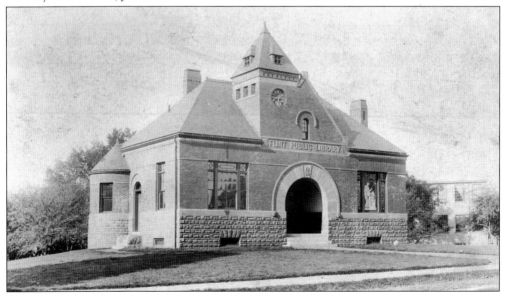

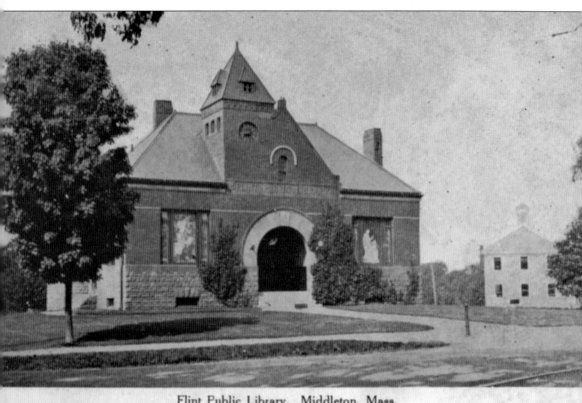

Flint Public Library, Middleton, Mass.

FLINT PUBLIC LIBRARY, C. 1899. This c. 1899 photograph shows a hitching post in front of the library, as well as the addition of a second stained-glass window in front of the library. Caroline Fuller donated the first stained-glass window in memory of her father, Jesse Fuller, the son of Simeon Fuller and grandson of Ephraim Fuller, whose house was removed so the Flint Public Library could be built on the property. Jesse Fuller was born in Middleton in 1803 and later moved to New York. The second stained-glass window is in the Trustees Room and represents Leigh Hunt's poem "Abou ben Adhem." The second stained-glass window was later given by Joseph N. Smith in memory of his wife, Caroline Fuller Smith. For many years after its opening, the Flint Public Library was only open for a few hours per week. Because transportation to the square became much more accessible and because of the demands of the citizens to have more availability, the library added more open hours for its patrons.

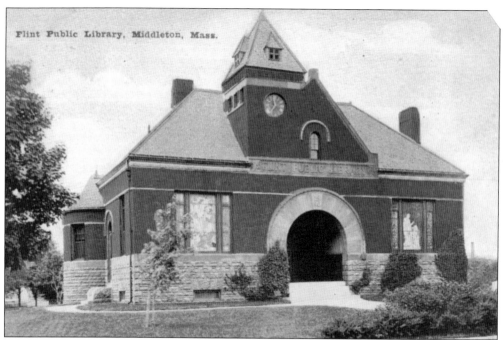

Flint Public Library, Middleton, Mass.

FLINT PUBLIC LIBRARY,
c. 1909. This penny postcard
view of the library shows
the addition of the second
stained-glass window. The
north-facing front entrance
was enclosed in the 1950s
by Carl Jones, a trustee of
the library, to protect it from
inclement weather. The clock
was donated by George Fuller
for the dedication in 1891.

CAROLINE A. FLETCHER
STILES. This photograph
is from a historical
daguerreotype taken in
1860. Caroline was one of
three members of her family
to serve as town librarian.
Samuel Fletcher, her father,
was the first librarian and
her sister Lillian followed
in her footsteps. Their
dear friend, Sally Carleton,
was the fourth librarian.

RUTH TYLER. Ruth was the granddaughter of Ansel P. Tyler, who was one of the first library trustees. She was the librarian at the Flint Public Library for many years and assisted the Middleton Historical Society in doing research for historical programs. Miss Tyler, as she was known to generations of children and library patrons, was dedicated to library service.

OLD TOWN HALL. Built in 1848, a whole story was razed to provide more meeting space. It became a senior center in the late 1980s. It was and still is in constant use for social, religious, and political meetings. The 1842 Annual Report for Middleton shows expenses for the year at nearly $1,300, including roads, schools, and welfare. The costs for running the town today are nearly $24 million. The population then was 657; in 2010 the population is over 8,000 people.

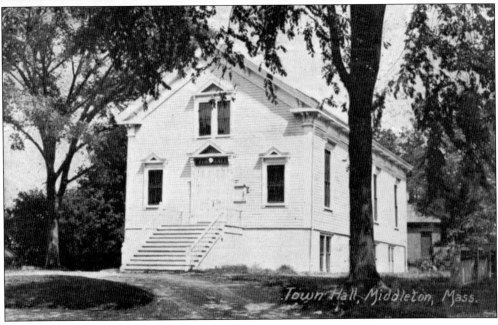

Town Hall, Middleton, Mass.

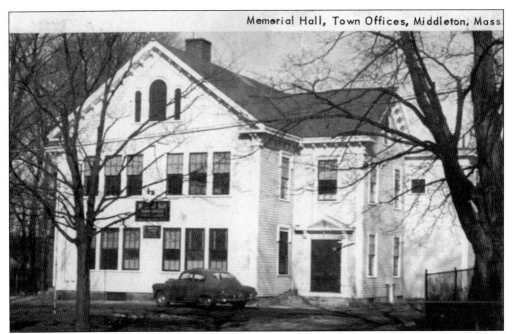

MEMORIAL HALL. All town offices are located in what used to be the Centre School. The building has been renovated several times and is well preserved and cared for by the town. After 1937, the building was renamed Memorial Hall in honor of all veterans.

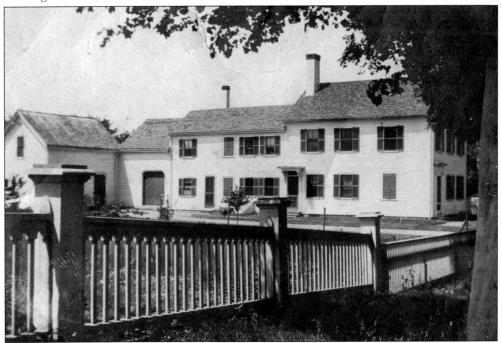

MIDDLETON POLICE STATION, 1950. Police Chief James Wentworth's office was located in his home on Maple Street across from the old town hall for all the years he served as chief. Middleton residents claimed the Chief Wentworth did not have a full night's rest for over 20 years. The police station was relocated to Memorial Hall in 1973.

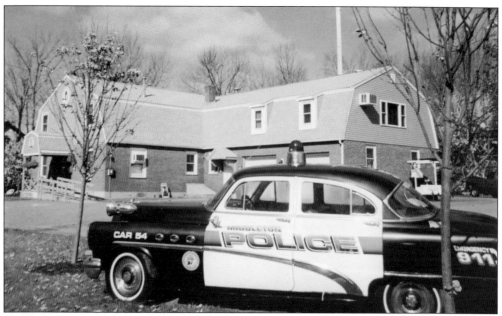

OLD POLICE CRUISER. This cruiser now sits on the front lawn of the Middleton Police Station. Police officers spent many hours in this old 1953 Buick police car patrolling the town of Middleton. In the background of this photograph, the Middleton Police Station can be seen. The Town of Middleton bought the police station from the Town of Danvers and moved it to its present location for $1.

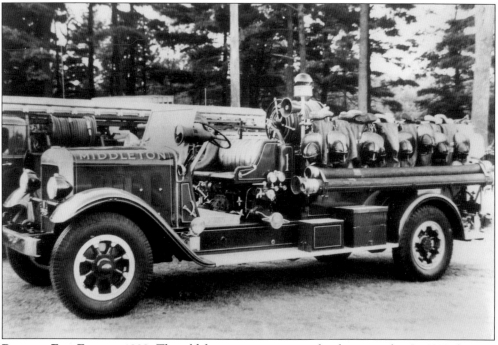

BUFFALO FIRE ENGINE, 1932. This old fire engine is now used only in parades. In 1910, firemen earned 25¢ per hour and they rented wagons and teams of horses from townspeople when they were needed. At present, the town's fully equipped and staffed firefighters carry on their mission. In addition, they provide ambulance service and medical assistance.

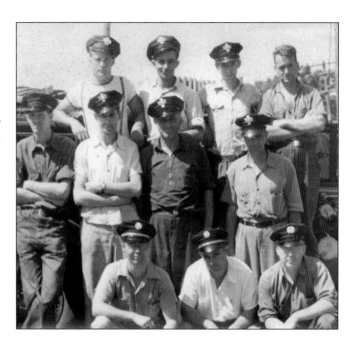

MIDDLETON FIRE DEPARTMENT. So many dedicated men have volunteered over the years to serve in the Middleton Fire Department. The only paid man in this photograph is part-time Chief Elmer Campbell Sr. The dedicated public servants in this picture are, from left to right, (first row) firefighters Elmer "Barney" Morrill, Ernest "Pete" Goodale, and Elmer Campbell Sr.; (second row) Arthur "Breezy" Page, Richard "Ricky" Goodale, Alfred "Kitch" Kitchen, and Ben Ogden; (third row) Buzzer Phaneuf, Charlie Clinch, James "Jim" Ogden, and Marshall Paine.

CERTIFICATE OF WAR NECESSITY. The Office of Defense Transportation issued this certificate for a 1935 dump truck to Middleton's highway department on November 6, 1943, as a form of rationing during World War II. Everyone did his or her part to assist in the war effort. Gasoline, butter, sugar, and tires were some of the things that were rationed. The Middleton Highway Department continues to care for roads, cemeteries, playgrounds, and all public grounds.

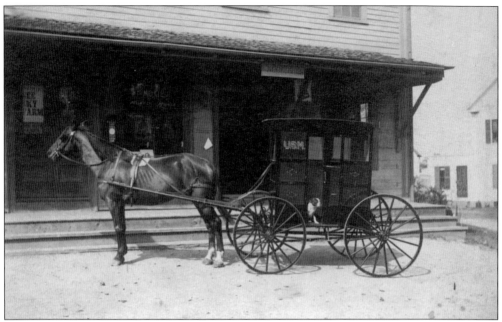

U.S. Mail. Before the rural free delivery system started in 1908, people picked up their mail at a central location. Oscar Cram, who operated a general store on Central Street, was the first postmaster. In any weather, this horse and wagon or sleigh was used to deliver the mail.

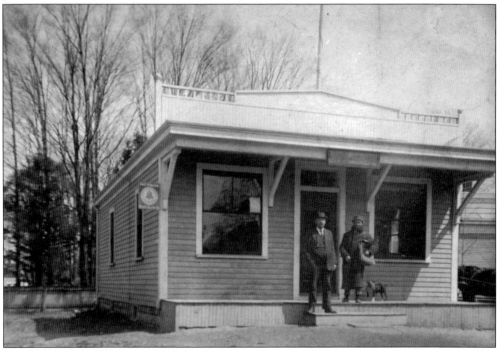

Early Post Office. Postmaster Oscar Cram stands here with Eugene Brown and his dog, Pinky. Brown was the first mail carrier in Middleton, and he delivered mail from 1908 to 1954. The post office also had the first public telephone. By the mid-1940s, most residents had party lines in their homes.

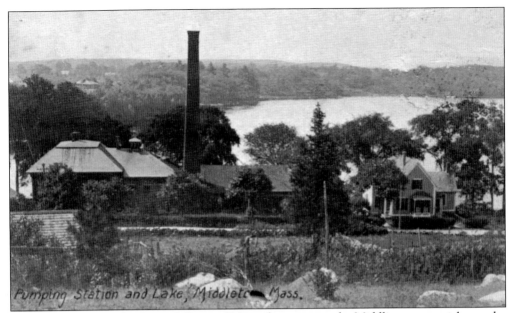

Pumping Station and Lake, Middleton, Mass.

PUMPING STATION. The General Court of Massachusetts gave the Middleton water rights to the town of Danvers in 1875 to meet the needs of Danvers State Hospital. Water rights included use of Middleton Pond and access to the Ipswich River. The pumping station is located on Lake Street next to Middleton Pond. William Hoelzel and his family were the last inhabitants of the superintendent's residence. Only the actual pumping station remains today.

WILL'S HILL RESERVOIR. The original reservoir was built on top of Will's Hill in 1896. In compensation for water rights, Danvers gave Middleton three fire hydrants located in Middleton Square, Oakdale Cemetery, and Howe Station. In 2010, town water has still not been extended to every home in Middleton, and some residents still rely on their wells.

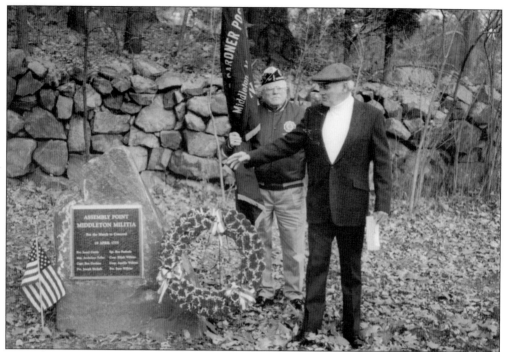

MIDDLETON MILITIAMEN. On April 19, 1775, eight Middleton Militiamen—Israel Curtis, Archelaus Fuller, Ben Gardner, Joseph Nichols, Ben Peabody, Aquilla Wilkins, Elijah Wilkins, and Enos Williams—marched to Concord to engage the British Regulars. A total of 125 Middleton men enlisted for the Revolutionary War, and two men died in the conflict. In 1997, a historical plaque was dedicated commemorating the courage of those brave militiamen. Robert W. Fox (in front), a decorated veteran of World War II, the Korean War, and the Vietnam War, conducted the dedication ceremony on Essex Street where the memorial is located. Holding the flag is a U.S. Navy veteran of the Korean War, John W. Mendalka Sr.

CIVIL WAR VETERANS. Civil War veterans are marching on Memorial Day in the 1920s. A note attached to the picture read, "Okay fellows, shape up just like we did when we marched down Pennsylvania Avenue in '65." (This referred to the end of the Civil War in 1865). Middleton sent 115 of its men to fight in the war to save the Union, and 16 died in the conflict. Of the 16 who died, four were the Guilford brothers and four were of the Fairfield family—a father and three sons.

WORLD WAR I HONOR GUARD.
Over 43 men from Middleton served
in World War I. One soldier, R.
T. Murphy, died in the war. This
photograph from Memorial Day
1919, shows, from left to right,
Alfred Kitchen, Ed Leary, Ray
Godfrey, and Ellsworth Barnaby.
The first permanent memorial
monument was erected on the
library lawn shortly after the war.

WORLD WAR I HEROES. This
picture was taken on May 30,
1919. From left to right are Otto
Currier, Frank Johnson, Myron
Wilkins, Lewis Rogers, Elsworth
Russell, Alfred Kitchen, W. Young,
Ed Leary, Raymond Godfrey,
Ellsworth Barnaby, Morrill Young,
T. (Doc) Mulkern, Chet Rogers,
Elmer Campbell, H. Jones, Earl
Jones, Bill Young, and Jim Hatch.

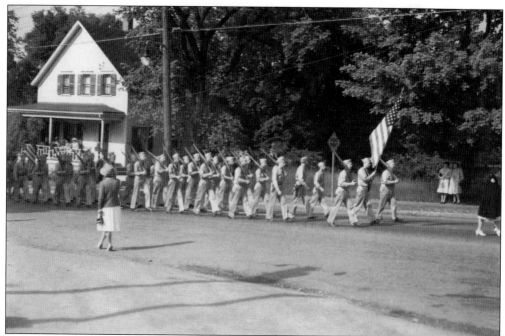

MASSACHUSETTS STATE GUARD. The Massachusetts State Guard marches in the Memorial Day Parade through Middleton Square in the late 1930s. Many of these men were among the first to enlist to serve their country during World War II. Hundreds of Middleton men and women served in World War II. The house in the background, now owned by Sam and Lois Lane Gianni, was built in 1859 on the site of the original town animal pound.

WORLD WAR II GUARDS. The above picture shows Wendell Durkee (right), the superintendent of the Danvers Water Department, and army boys guarding the Middleton pumping station against poisoning of the water supply during World War II. The soldiers were stationed at Camp Curtis Guild in Wakefield, Massachusetts. Engineer William Hoelzel and his wife, Myrtle, and their family resided on the property at Middleton Pond. Note the old beach wagon.

RUBBER SALVAGE. This picture shows a huge stack of tires for salvage in front of Stahler's garage in 1942. Travel was greatly curtailed or cancelled during World War II, when gasoline and tires were strictly rationed. Pictured here from left to right are Harley Wood, George Stahler, Ray Nelson, Richard Paulsen, and John Bishop.

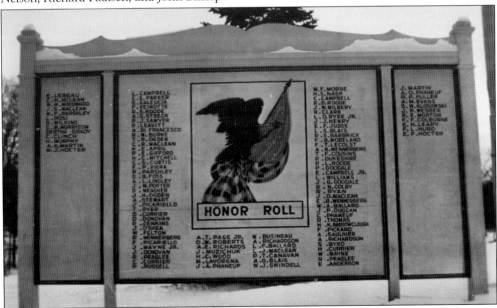

WORLD WAR II HONOR ROLL. The townspeople of Middleton honored their men and women who served in World War II; there were 191 men and women who served. This wooden commemorative honor roll was displayed during World War II on the Flint Public Library lawn in Middleton Square. Ten men from Middleton gave their lives during World War II: Robert Burke, David Currier, Charles Curtis Jr., Joseph Donovan, Gardner Galeucia, Donald Meagher, Alfred Phaneuf, Russell Roode, Lewsis Ryer Jr., and Alvar Wennerberg. All of these men have streets named after them in Middleton. In this area now are several permanent war memorials.

WORLD WAR II. This photograph is of World War II soldiers being honored by a parade in Middleton after the war. Shown are Mike Lavorgna (left), Douglas Seaver (center), and Elmer Campbell Jr. (second from right), who went to war as boys and came home as men.

MONUMENTS ON LIBRARY LAWN. These monuments are dedicated to the men and women who served in World War I, World War II, the Korean War, and the Vietnam War. The Korean Memorial and the Vietnam Memorial were both dedicated on November 11, 1981, and the featured speaker was Gen. George Patton Jr. Seventy-four men and women served in the Korean War, and 140 men and women served in Vietnam. The only Middleton death in Vietnam was Lt. John Cabral, U.S. Navy.

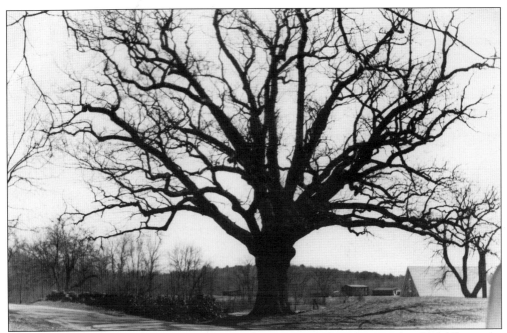

THE GREAT OAK TREE. The Great Oak has been a symbol to the people of Middleton for many generations. It is a species of white oak, and it is believed to be over 400 years old and 38 feet in circumference. There are those who believe it is also a symbol of liberty, as was the Liberty Tree.

THE LURA WOODSIDE WATKINS MUSEUM. The museum is located on Pleasant Street and is the home of the Middleton Historical Society. The museum was built in 1976 and dedicated in 1977. Ray Farnsworth of Kenney Road was the project manager. The first curator was John Deering of Maple Street, who was instrumental in soliciting the collection.

BIBLIOGRAPHY

Dow, George Francis. *Vital Records of Middleton to the End of the Year 1849*. Topsfield, MA: Topsfield Historical Society, 1904.

Flint, George B. Diaries, 1853. Flint Public Library, Middleton, MA.

Flint, John. *A Genealogical Register of the Descendants of Thomas Flint of Salem*. Andover, MA: W. F. Draper, 1860.

Hill, William Carroll. *The Family of Bray Wilkins: Patriarch of Will's Hill, of Salem (Middleton), Mass*. Milford, NH: Cabinet Press, 1943.

Ingalls, Moody and Farnum. Blacksmithing account book, 1826–1834 mss. Flint Public Library, Middleton, MA.

Manual of Evangelical Congregational Church in Middleton. Middleton, MA.

Massey, Dudley A., ed. *History of Freemasonry in Danvers, Mass. From September, 1778, to July, 1896*. Peabody, MA: Press of C. H. Shepard, 1896.

Nevins, Winfield S. *Witchcraft in Salem Village in 1692*. Salem, MA: North Shore Publishing Company, 1892.

The Origin of the Church of Christ in Middleton. Salem, MA: Register Press, 1850.

Perley, Sidney. *The History of Salem, Massachusetts*, 3 volumes. Salem, MA: 1924–1928.

Rice, Charles B. *History of the First Parish of Danvers, 1672–1872*. Boston, 1874.

Smith, Elias. George Peabody Notes, Poems and Sermons, includes History of the Church in Middleton, Memoir of Rev. Ebenezer Hubbard, Memoir of Dr. Silas Merriam. Flint Public Library

Hurd, D. Hamilton, ed. *History of Essex County, Massachusetts*, 2 vols. Philadelphia: J. W. Lewis and Company, 1888.

Watkins, Lura Woodside. *Middleton, Massachusetts: A Cultural History*. Salem, MA: Essex Institute, 1970.

Webber, C. H., and W. S. Nevins. *Old Naumkeag: An Historical Sketch of the City of Salem*. Salem, MA: A. A. Smith and Company, 1877.

White, Henry H. *Men of Middleton Who Enlisted in the Union Army, 1861–1865*. Middleton, MA, 1909.

About the Middleton Historical Society

The Middleton Historical Society is a private nonprofit organization founded in 1954 to preserve, research, and communicate the cultural and political history of the town of Middleton. The Middleton Historical Society is situated in the Lura Woodside Watkins museum, which houses an extensive collection of 18th-, 19th-, and 20th-century artifacts. The society owns, maintains, and operates the museum, which offers lectures, cultural events, and special programs for its members and the community.

The museum manages a collection of photographs, rare books, letters, diaries, manuscripts, newspaper clippings, and over 1,000 artifacts unique to Middleton. For further information, contact the society at P.O. Box 456, Middleton, Massachusetts 01949.

BERTHA WOODWARD AND LURA WATKINS. Pictured above left *c.* 1949 is Bertha Flint Woodward, founder of the Middleton Historical Society. Pictured above right *c.* 1950 is Lura Woodside Watkins, a respected author of history for whom the museum is named.

www.arcadiapublishing.com

Discover books about the town where you grew up, the cities where your friends and families live, the town where your parents met, or even that retirement spot you've been dreaming about. Our Web site provides history lovers with exclusive deals, advanced notification about new titles, e-mail alerts of author events, and much more.

MADE IN THE **USA**

Arcadia Publishing, the leading local history publisher in the United States, is committed to making history accessible and meaningful through publishing books that celebrate and preserve the heritage of America's people and places. Consistent with our mission to preserve history on a local level, this book was printed in South Carolina on American-made paper and manufactured entirely in the United States.

This book carries the accredited Forest Stewardship Council (FSC) label and is printed on 100 percent FSC-certified paper. Products carrying the FSC label are independently certified to assure consumers that they come from forests that are managed to meet the social, economic, and ecological needs of present and future generations.

FSC

Mixed Sources
Product group from well-managed
forests and other controlled sources

Cert no. SW-COC-001530
www.fsc.org
© 1996 Forest Stewardship Council

Find Your Place in History.